The Return of

THE CADAVRE EXQUIS

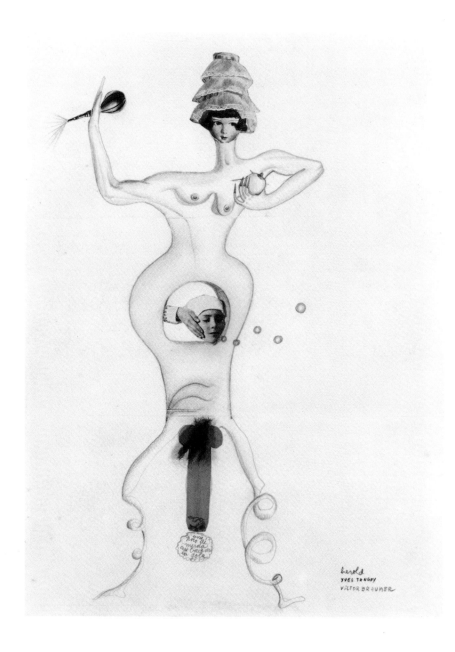

Jacques Hérold, Yves Tanguy, and Victor Brauner, *Cadavre Exquis*, circa 1932

The Return of

THE CADAVRE EXQUIS

THE DRAWING CENTER

Sergio Bessa, Darren Brown, Vik Muniz, and Kellie O'Bosky, 1993

Exhibition Itinerary

The Drawing Center, New York
November 6 – December 18, 1993

The Corcoran Gallery of Art, Washington, D.C.
February 5 – April 10, 1994

Santa Monica Museum of Art
July 7 – September 5, 1994

Forum for Contemporary Art, St. Louis
September 30 – November 12, 1994

American Center, Paris
December 1994 –January 1995

...
The catalogue for "The Return of the Cadavre Exquis"
has been made possible in part with generous grants
from the Elizabeth Firestone Graham Foundation
and two anonymous donors.

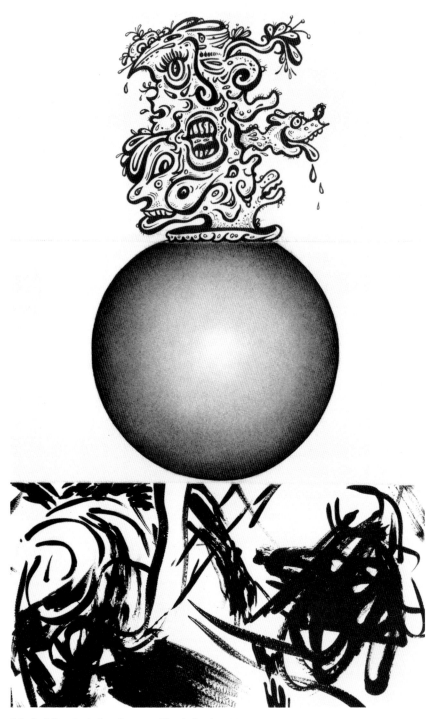

John Paul Crangle, Andrew Fenner, and Lynda Benglis, 1992

Contents

8 **FOREWORD**
Ann Philbin

8 **PARTICIPATING ARTISTS**

11 **ACKNOWLEDGMENTS**

15 **IN ADVANCE OF
"THE RETURN OF THE CADAVRE EXQUIS"**
Ingrid Schaffner

25 **THE LITTLE VENUS OF THE ESKIMOS**
Charles Simic

33 **EXQUISITE ESSENTIALS**
Mary Ann Caws

43 **APRÈS EXQUIS**
Essays by Ingrid Schaffner
with a contribution by Elizabeth Finch

45 *Surrealism*
47 *Surrealisms*
48 *Games*
56 *Collaboration*
57 *Collage*
61 *Grotesque*
68 *Sex*
68 *The Corpse*
69 *Time and the Body*

75 Historical Works

77 Contemporary Works in the Traveling Exhibition

Participating Artists

Eduardo Abaroa
Matthew Abbott
Sigmund Abeles
Fabienne Abrecht
Mac Adams
Roland Aeschlimann
Afrika
Richard Agerbeek
Hanno Ahrens
Elizabeth Albert
Susan Albrecht
Charles Allcroft
Doug Allen
John Allen
Phillip Allen
Stavit Allweis
Desiree Alvarez
William Anastasi
John Kirk Anders
Chris Anderson
Curtis Anderson
Laura Anderson
Laurie Anderson
Erica Ando
Tiong Ang
James Angell
Suzanne Anker
William Anthony
Miroslav Antic
Jean Philippe Antoine
Janine Antoni
Bill Antonow
Dan Appel
Ida Applebroog
Tomie Arai
Derrick Armor
Kenseth Armstead
L.C. Armstrong
Richard Artschwager
Greg Asch
Mike Asente
Eve Ashcraft
Dan Asher
Doug Ashford
Dotty Attie
Julie Ault
Donna Avedisian
Lauriston D. Avery
Roderigo Avila
Alice Aycock
Olive Ayhens
Gail Bach
Lutz Bacher
Gary Bachman
Donald Baechler
Enver Baikeev
Eric Bainbridge
Tara Balco
John Baldessari
Gary Bandy
Vernon Banister
Rudolf Baranik
Allen Barber
Marty Bargeron
Al Barna
Sarah Barnum
Bill Barrette
Jack Barth
Georg Baselitz
Lisa Bateman
Suzan Bath
Karen Bauer
Drew Beattie and
Daniel Davidson

FOREWORD

"The Return of the *Cadavre Exquis*" is the long-awaited result of a proposal brought to The Drawing Center nearly three years ago by independent curator Ingrid Schaffner, with artists Kim Jones and Leonard Titzer. Inspired by the studio *cadavre exquis* collaborations of Jones and Titzer, Ms. Schaffner envisioned this surrealist parlor game as the focus of an exhibition project engaging a large and diverse group of contemporary artists. We are extremely grateful to the more than one thousand artists who have generously participated as well as to the individuals and institutions who have graciously lent their historic *cadavres exquis* drawings. In this respect, I would like to thank the following lenders: Robert A. Baird, Timothy and Tristan Baum, Lucienne Bloch, Ted Joans, Konrad Klapheck, the Indiana University Art Museum, The Metropolitan Museum of Art, and The Museum of Modern Art.

This project became international through the assistance of many enthusiastic colleagues who organized artists' collaborations abroad. We offer our thanks to Marco Colapietro in Rome, Dana Friis-Hansen in Tokyo, Paul Judelson in St. Petersburg, Andrew Nairne in Glasgow, Cristiana Perrella in Rome, Marina Skipsey in Mexico City, Sandro Sproccati in Bologna, Jolie van Leeuwen in Amsterdam, and Gordon VeneKlasen in Cologne.

When this current round of *cadavre exquis* began, there was no way of anticipating the tremendous response our invitation to "play" would receive. Indeed, in our commitment to let the game run its natural course, the exhibition was twice postponed and the ranks of artists continued to swell. In the true spirit of chance, we decided to exhibit all the drawings we received, which eventually counted over six hundred. Our deepest gratitude is extended to Mariacristina Parravicini for making this complete presentation possible by donating her gallery for additional exhibition space, and to Peter Tunney for this fortuitous introduction.

I am also indebted to the esteemed members of our jury for lending their time and expertise to the selection of the contemporary works for the traveling component of the exhibition. Timothy Baum, Klaus Kertess, Francis Naumann, and Martica Sawin helped break many a curatorial gridlock during the difficult process of winnowing hundreds of successful and beautiful *cadavres exquis* into a representative group. For this exhibition catalogue we are indebted to Charles Simic, Pulitzer Prize-winning poet, for his enchanting meditation on chance, and to Mary Ann Caws, distinguished professor of English, French, and comparative literature, Graduate Center, the City University of New York, for her scholarly insights on historic *cadavres exquis*.

I would also like to thank Terry Sultan, curator, The Corcoran Gallery of Art, Washington, D.C.; Thomas Rhoads, director, Santa Monica Museum of Art; Betsy Millard, director, Forum for Contemporary Art, St. Louis; Frederick B. Henry, co-chairman, Board of Trustees, and Henry Pillsbury, director, the American Center, Paris, for their commitment to present this exhibition at their institutions.

Participating artists have graciously and generously donated their drawings to benefit The Drawing Center. Works were offered to collectors and patrons through a random lottery, which allowed the element of chance to govern the game to its conclusion. I greatly appreciate the support of our Benefit Committee, Alain Clairet, Eileen Cohen, Curt Marcus, Matthew Marks, Neal Meltzer, Marc Selwyn, Jennifer Wells, and Thea Westreich, and benefit coordinator Ellen Salpeter. I would also like to thank the Members of the Board of Directors of The Drawing Center for their early and continuing support of this project.

Nancy Brooks Brody
Gary Brotmeyer
Christian Brown
Darren Brown
Trisha Brown
Jamie Brunson
Deborah Buck
Kavin Buck
Carmel Buckley
Ken Buhler
Leonard Bullock
Rudy Burckhardt
Tom Burckhardt
Peter Burgess
Kathe Burkhart
Linda Burnham
Charles Burns
Berta Burr
William Burroughs
Dina Bursztyn
Richmond Burton
Kendall Buster
Ken Butler
Luca Buvoli
Helaina Buzzeo
Stephen Byram
David Byrne
Michael Byron
Peter Cain
Andrea Callard
Frank Camarda
Luis Camnitzer
Karin Campbell
Roberto Caracciolo
Rimer Cardillo
Rob Carducci
Hilary Carlson
Mary Carlson
Squeak Carnwath
Carole Caroompas
David Carrino
Mary Ellen Carroll
Josely Carvalho
James Casebere
Cheryl Casteen
Rolando Castellon
Rosemarie Castoro
Francisco
 Castro Lenero
Joe Cavallaro
Hermosa Cerda
Fabián Cereijido
Enrique Chagoya
Patrick Chamberland
Jo Bean Chambers
Andrea Champlin
Michael Chandler
Karen Chaplin
Sarah Charlesworth
Emily Cheng
Sergei Chernov
Chris Chevins
James Chiang
Taro Chiezo
Russell Christian
Clark Christie
Y. David Chung
John Clark
Larry Clark
Francesco Clemente
Dawn Clements
Chuck Close
Maurice Cockrill
Mike Cockrill
Arthur Cohen

Not surprisingly, "The Return of the *Cadavre Exquis*" has been a vast and nearly overwhelming administrative project. It could not have been accomplished without the exceptional abilities of Elizabeth Finch, exhibition coordinator, who worked logistical wonders and contributed invaluably to the development and realization of this exhibition and catalogue. I would also like to thank the other members of my staff for their energy and commitment: Cecilia Clarke, James Elaine, Sarah Falkner, Peter Gilmore, and Gloria Williams as well as the numerous interns who generously lent a hand with hours of tracking, registering, labeling, and researching the many drawings. In addition special thanks are extended to Bethany Johns and Georgianna Stout for the elegant design of this catalogue. Finally, this project would not have been possible without the vision of Ingrid Schaffner, who recognized the compelling contemporary relevance of the *cadavre exquis* practice and contributed a thought-provoking and spirited essay on the subject. It has been a great pleasure to work with her.

This catalogue has been made possible in part with generous grants from the Elizabeth Firestone Graham Foundation and two anonymous donors. We most gratefully acknowledge their support.

Ann Philbin
Director

ACKNOWLEDGMENTS

To Ann Philbin's foreword, I would like to add my personal thanks to the following people. To Andrei Codrescu who shared with me, early on, his "coffins" full of *cadavre exquis* experience. To William Kennon for his research assistance, and to Paola Morsiani for her thoughtful attention to the project of cataloguing the contemporary drawings. To those individuals who helped me to hunt historic *cadavre exquis*, especially: Timothy Baum, Lucienne Bloch, Dominique Bürgi, Robert Everon at The Museum of Modern Art, Ted Joans, and Konrad Klapheck. To Geoffrey Batchen and JoAnn Schaffner, who read early versions of my essays and to Jane Philbrick, who edited the final text.

Most of all, I would like to thank Kim Jones and Leonard Titzer, who, along with each of the artists who played, have kept the Exquisite Corpse so alive, so well.

Ingrid Schaffner

Elaine Lustig Cohen
Tamar Cohen
Robert Colescott
Greg Colson
Christopher Combs
Elisabeth Condon
Maureen Connor
M.J. Connors
Dennis Cooper
Fred Corbin
Denise Corley
Impala Corona
Catharina Cosin
Chris Costan
Amelia Costigan
Cornelia Cottiati
Laura Cottingham
Pat Courtney
Adger Cowans
Moyo Coyatzin
John Paul Crangle
Jane Creech
Kara Cressman
Nina Crews
Critical Art Ensemble
Patricia Cronin
Jennifer Croson
Ford Crull
Abraham Cruz Villegas
Robert Cumming
Merce Cunningham
Margaret Curtis
Elisa D'Arrigo
Doug Daffin
Mark Daggett
Hilary Daley-Hyies
Ann Dalou
Ann Daly
Lydia Dana
Richard Dana
Valery Daniels
Gregory Davidek
Betsy D. Davis
Don Davis
Chris De Boschnek
Michael De Jong
Stephan de Kwiatkowski
Ernesto de la
Vega-Pujol
Christine De Lignieres
Brett De Palma
Ana de Portela
Lucky DeBellvue
Scott DeDecker
Georganne Deen
Patsy Degener
Steve DeFrank
Steve Deihl
Anne Deleporte
Marina Delfini
Maria Demarse
Donna Dennis
Jeffrey Dennis
Tory Dent
Steve Derrickson
Eddy Deutsche
Diedre Dewart
Alberto Di Fabio
Stefano Di Stasio
Jane Dickson
Vincent Digerlando
Lesley Dill
Stephen Pope Dimitroff

11

continues on page 72

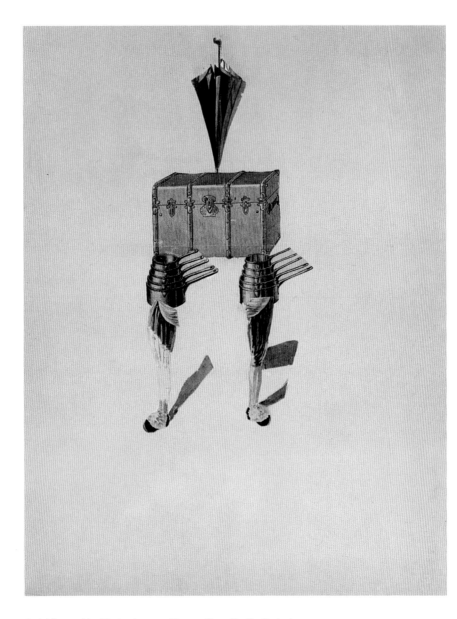

André Breton, Max Morise, Jeannette Tanguy, Pierre Naville, Benjamin
Péret, Yves Tanguy, and Jacques Prévert, *Figure (Cadavre Exquis)*, circa 1927.
This collage accompanied the original definition of *cadavre exquis* that
appeared in the 1938 *Dictionnaire abrégé du surréalisme.*

CADAVRE EXQUIS : Jeu de papier plié qui consiste à faire composer une phrase ou un dessin par plusieurs personnes, sans qu'aucune d'elles puisse tenir compte de la collaboration ou des collaborations précédentes. L'exemple, devenu classique, qui a donné son nom au jeu tient dans la première phrase obtenue de cette manière: LE CADAVRE-EXQUIS-BOIRA-LE VIN-NOUVEAU.

EXQUISITE CORPSE : Game of folded paper which consists in having several people compose a phrase or a drawing collectively, none of the participants having any idea of the nature of the preceding contribution or contributions. The now classic example, which gave its name to the game, is the first phrase obtained in this manner: THE EXQUISITE-CORPSE-SHALL-DRINK-THE YOUNG-WINE.

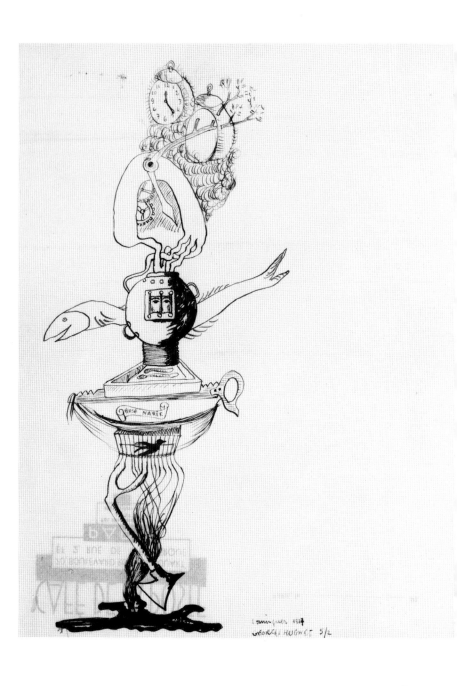

Oscar Dominguez and George Hugnet, *Rose Marie (Cadavre Exquis)*, 1937

14

In advance of

THE RETURN OF THE CADAVRE EXQUIS

Le Cadavre exquis a l'honneur de vous faire part de la réouverture de la Galerie surréaliste 16, rue Jacques-Callot qui aura lieu le lundi 10 Octobre 1927 à 3 heures de l'après-midi.[1]	The Exquisite Corpse has the honor of inviting you to the reopening of la Galerie surréaliste at 16, rue Jacques-Callot taking place Monday, October 10, 1927 at 3 o'clock in the afternoon.

\mathcal{M}aking one of his first public appearances, *le cadavre exquis* was the subject of the reopening exhibition of la Galerie surréaliste, in Paris in 1927.[2] Had we attended this event, we would have experienced the surrealist movement in its heyday and found *le cadavre exquis* in his prime. An honored guest at any gathering, the Exquisite Corpse was the *enfant terrible* of surrealist games: a metamorphic being, cropping up not only at exhibitions but at café tables, in hotel rooms, even once strolling the Ramblas in Barcelona, where, artist Marcel Jean recollects, "crowds filled the café terraces until late at night, clapping hands to call the waiters so that we imagined that they were cheering us as we passed by."[3]

* ·

Exquisite Corpse, among the most widely enjoyed of the surrealists' many games, sought to unleash the unconscious in a merry chase of the imagination. Realized through automatic drawing, a technique—nearly synonymous with surrealism—which charted the irrational, unstoppable flow of words and images that channels through thought without conscious reflection, and assembled by chance, there is not a rational bone in

SURREALISM, n.:
Pure psychic automatism by whose means it is intended to express verbally, or in writing, or in any other manner, the actual functioning of thought. Dictation of thought, in the absence of all control by reason and outside of all aesthetic or moral preoccupations.

—André Breton,
Manifeste du surréalisme, 1924[4]

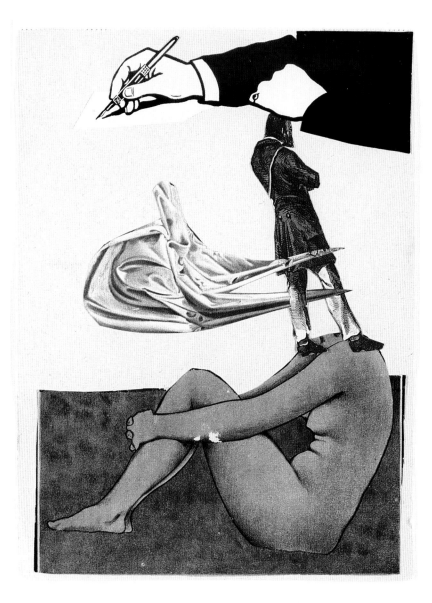

Marcel Jean,
Oscar Dominguez,
and Estéban Francès,
Cadavre Exquis, 1935

le cadavre exquis. Culled from the minds of more than one individual, he emerged as though from a dream. Indeed the Corpse's generally grotesque appearance bespoke an alternate beauty, of a harmony in rupture. As a figure of revolt that drew the surrealists together through collaboration, *le cadavre exquis* provided the common ground upon which these artists waged their assault on sobriety and logic.

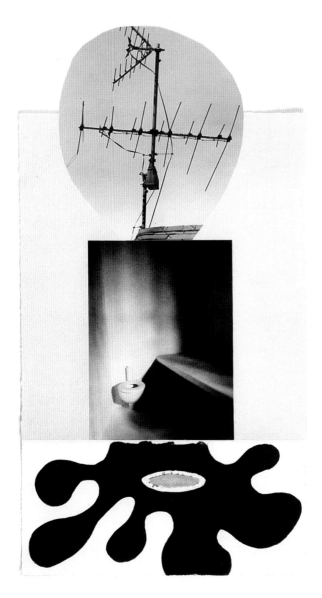

Since those youthful salad days, the Exquisite Corpse has
retired to a relatively reclusive life amongst artist-friends
and children—until April 1991 and "The Return of the
Cadavre Exquis." Opening this current round, The Drawing
Center invited artists from all conceptual orientations, at
all points in their careers, from all over the world to join in
the game. As word of the project spread, foundling corpses

Tony Oursler,
James Casebere,
and Charles Golden,
1993

began to appear on The Drawing Center's doorstep. To date, the initial list of some two hundred participating artists now counts at least twelve hundred players, and their drawings number more than six hundred.

Poetry must be made by all, not one.
—compte de Lautréamont, *Poesies*[5]

····························· *

The *cadavre* is a single sheet of paper, divided according to the number of players into segments that roughly correspond to the human body; i.e. head/torso/legs for three players, or, head/chest/trunk/legs for four players. Many artists introduced their own variations. Ellsworth Kelly (who first played *cadavre exquis* as a young artist knocking around Paris with the surrealists) and Win Knowlton made a four-part *cadavre* by playing two rounds each. Another tiny corpse was carved into ten small but satisfying portions. As the game is played, each artist, working in turn, completes a section and conceals the work before passing it on to the next artist. When all the sections are finished, the drawing is unfolded and the Exquisite Corpse is born.

The cords that bind this present-day manifestation to the original Exquisite Corpse are only loosely in the hands of its originator, André Breton. The element of automatism—so critical to the original players and impossible to reproduce in any pure sense—is almost entirely absent today. Equally indistinct are surrealism's claims to marry everyday reality and dreams, although the imagination still reigns supreme. Exerting their considerable presence on this most recent round are Marcel Duchamp, with his conceptual approach to game-playing and object-making, and Georges Bataille, with his energetic aberrance for rules and taboos. Add to this skein of historical influences the contemporary threads of psychoanalysis, deconstruction, and anthropology—all closely bound to surrealist practice and worked into the complex analytical fabric of postmodernism.

*

Art movements are simply not recursive. These new *cadavres* were not cultivated through cryogenics. Contemporary artists with their own inventive insights have participated to create a body of work which is vigorous and

intuitive precisely because it is not corsetted by the past. In lieu of the mainstays of Breton's game comes an unprecedented expansion of the definition of drawing itself, a practice that now appears to encompass everything from pricking to poetry. What remains essential, because it can be replayed, is the game. Precisely because of its value as play, Exquisite Corpse continues to offer a means of sidestepping reason and foresight to move towards chance and unpredictability. Ultimately, as a collective revelation of artistic imagination, "The Return of the *Cadavre Exquis*" still answers André Breton's eternal appeal to artists: "Speak according to the madness that has seduced you."[6]

<p style="text-align:center">*</p>

Players of the contemporary game were at liberty to paint, paste, clip, jot, scribble, and sculpt according to their own predilections on paper. They were also encouraged to consider the "body" as a metaphoric point of departure. In Exquisite Landscape, a variation of *cadavre exquis*, the surrealists took similar license.[7] Here, players contributed to a horizontal floe of objects and images that unfolded like a map onto psychic space or dream reality. Playing the game in 1975 with colleagues Anna Boetti and Roberto Lupo, Meret Oppenheim adapted the anatomy of the body (head/trunk/legs) to the structure of a chair (back/seat/legs) to create a series of unusual *cadavres exquis*.[8] Nevertheless, most of the contemporary *cadavres exquis* adhere to the conventional structure of the human body.

Meret Oppeheim, Roberto Lupo, and Anna Boetti, *Stuhl in einem Wasserfall* (*Chair in a Waterfall*), 1975 (unfinished). Graphite, 16 5/8 x 11 1/2 inches. Private collection.

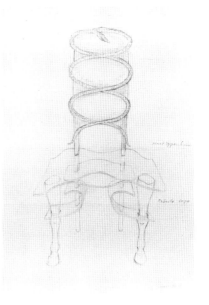

As postmodernism's most prevalent subject and site, the body has been used by contemporary artists to explore issues of identity and gender, public health and private pleasure. It is a complicated realm, inscribed with sexual and cultural codes that catalogue human difference as opposed to universal experience. The body can no longer be mirrored in an impervious white model handed down from antiquity, nor in

the hirsute primitive archetype called forth by modernity. Sweeping these old ideals aside, the Exquisite Corpse, with his collective and composite physique, flaunts a relevant contemporary image of the body.

The *cadavre* is also an appealingly social creature. His appearance in the wake of recent political events stands to link members of a cultural community still reeling from battles over censorship and support. The conservative backlash against government aid for the arts—a curious election-time diversion from real moral and economic crises—has left artists and the public each wary of the other's capacity to appreciate or simply enjoy art. As he engages the artworld at large in a constructive creative act, the *cadavre* is a Pollyanna assembled by Dr. Frankenstein advocating the primacy of visual practice, however conceptual, in art.

................................ *

Participating artists were given the choice of either selecting their own partners or allowing The Drawing Center to choose for them. While the first option more closely matches the surrealist practice of sitting around a table with like-minded colleagues and passing round the *cadavre exquis*, the latter invites a further element of chance. Apparently some of the more intimate sessions really took off, as we received entire sheaves of *cadavres exquis* from some self-made groups. A number of artists played with their assistants, casting at least one studio into an uproar of anxiety until the game turned from an employee's nightmare into an impromptu party. Approximately half of the players allowed The Drawing Center to select their partners for them. In general we aimed to create unified bodies, however discordant the parts.

To facilitate the project, we created a Drawing Kit with a set of rules instructing artists how to play the game. Seemingly antithetical to artistic practice, rules can actually clear the way for chance and liberate the imagination. Playing within prescribed parameters, one surrenders the pull of reason to the pleasure of adhering to (and breaking)

rules. Not surprisingly, we learned from some honestly dishonest players that many of the visual coincidences which occur in these drawings were not the outcome of what Breton divined to be "tacit communication—merely by waves—among the players."[9] These riddles of concurrence are often signs of cheating. However, as Mary Ann Caws and Charles Simic each suggest in the essays which follow, bending the rules of chance is also part of the tradition of surrealist games.

Included in the kit was a paper sleeve (printed with abridged guidelines) that concealed the nascent *cadavre* while disclosing a slender reveal. This edge, a perceptual point of orientation, served as a prompt or segue into the players' unconscious. Two differently sized sheets of paper were provided, although artists could and did use their own supports. In one case this was sandpaper and in another a string of nineteenth-century maps. Drawing materials were even more various, including everything from lipstick to operative light-bulbs, from pot holders to x-rays. Likewise, applications coursed from stitchery to photography, from slashing to burning. Several *cadavres* were machined with the aid of computers. And still, many unexpected images came by the traditional (graphic) route of pencil on paper.

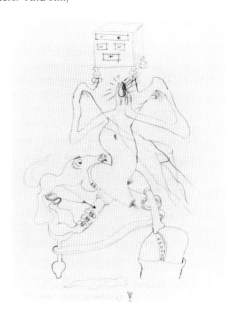

Lilo Klapheck, Joseph Beuys, Konrad Klapheck, and Eva Beuys, *Odysseus Circe Betrachtend* (*Ulysses Watching Circe!*), 1961. André Breton wrote the catalogue text for an exhibition of paintings by Konrad Klapheck held in 1965 at galerie Sonnabend, in Paris. Prior to this, from 1961 to 1963, Klapheck regularly played *cadavre exquis* with other artists and friends, including Joseph Beuys and Gerhard Richter.

*

In New York, all the works generated by the "*Cadavre Exquis*" were exhibited at The Drawing Center and a nearby gallery space. In addition, a selection of historic *cadavres exquis* were on view at The Drawing Center, including drawings by original players, Valentine Hugo, Marcel Jean, and Yves Tanguy. Latter-day *cadavres* by Joseph Beuys, Lucienne Bloch, Ted Joans, Frida Kahlo, Konrad Klapheck, Wifredo Lam, Roberto Matta, and Gerhard Richter,

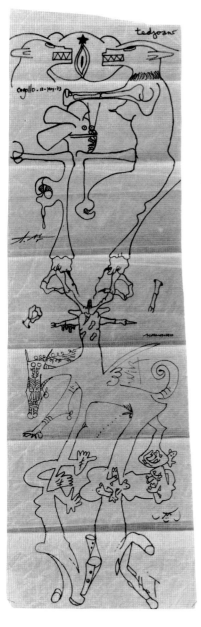

among others, attested to the continuing vitality of the Exquisite Corpse.[10]

Certainly not all collaborations work. Simone Collinet wrote of the literary version of *cadavre exquis* that: "Some sentences took an aggressively subversive existence. Others fell in an excessive absurdity. The wastebasket played its part. Let us not forget it."[11] At The Drawing Center, this editorial apparatus did not come into play. Even with overwhelmingly exquisite results, the degrees of and reasons for the success of these collaborations are as diverse as any other aspect of the project. Some drawings are cursive and comic, others are rendered and wry, with the bizarre, horrifying, overwrought, satiric, disgusting, beautiful, fragile, boisterous, delicate, goofy, brutal, feminist, misogynist, political, precious, and poignant all putting in appearances. As spectators, may we be ravished by the pleasure of looking at so many ways of seeing. Or, at least, mindful of André Breton's charge, "Beauty will be CONVULSIVE or will not be at all."[12] —*I.S.*

Ted Joans, Heriberto Cuadrado Cogollo, Agustín Cárdenas, Jorge Camacho, Wifredo Lam, Roberto Matta, and Hervé Télémaque, *The Seven Sons of Lautréamont*, 1973-80

Notes

1. This text was accompanied by the *cadavre exquis* (p. 12); in André Breton, *Le cadavre exquis, son exaltation* (Milan: Chez Arturo Schwartz, 1975), p. 16.

2. The gallery, directed by Jacques Tual, with André Breton as advisor, first opened March 26, 1926, with an exhibition of paintings by Man Ray juxtaposed with Oceanic sculpture from the collections of Louis Aragon, Breton, Paul Eluard, and others.

3. From Marcel Jean's description of his trip to Barcelona in July 1935 and the *cadavre exquis* he created there with artists Oscar Dominguez, Estéban Francès, and Remedios Varo, (pp. 16, 74). Quoted in Cynthia Jaffee McCabe, "The Rewards of Leisure," *Artistic Collaboration in the Twentieth Century* (Washington, D.C.: Smithsonian Institution Press, 1984), p. 32.

4. André Breton, quoted in Marcel Jean, ed., *The Autobiography of Surrealism* (New York: The Viking Press, 1980), p. 123.

5. Ibid., p. 52.

6. André Breton, quoted in Franklin Rosemont, ed., *What is Surrealism?: Selected Writings* (Chicago: Monad Press, 1978), p. 59.

7. Following the lead of The Drawing Center, The Swiss Institute in New York recently made Exquisite Landscapes the subject of an exhibition project called "A Grand Tour," which was on view from March 4 to April 4, 1993.

8. This same group also experimented with three-dimensional *cadavre exquis*. Oppenheim describes, "Armed with plastic bags, we walked out of the village and each gathered whatever we saw lying on the path or in the fields or woods that caught our eye.... In the end, all the nine figures plus titles were brought out one after the other and placed on a shelf. The correspondence between title and figure was astonishing." Quoted in Bice Curiger, *Meret Oppenheim* (Zurich: Parkette Publishers, 1989), pp. 207-08.

9. André Breton, *Le cadavre exquis*, p. 12.

10. Indeed, as we conclude our game, the world's longest *cadavre exquis*, the brainchild of American expatriate poet, Ted Joans, continues to unfurl. This drawing, titled *Long Distance*, was "started by chance when I [Jones] found some folded sheets of computer paper in London 1975....The number as of this date March 11 1993 is 120." Participants include Romare Bearden, Paul Bowles, Allen Ginsburg, Dick Higgins, and Micheal Leiris. Joans, quoted from a letter to the author, March 11, 1993.

11. Simone Collinet, quoted in André Breton, *Le cadavre exquis*, p. 30.

12. André Breton, *Nadja*, Richard Howard, trans. (New York: Grove Press, 1960), p. 160; originally published in 1928.

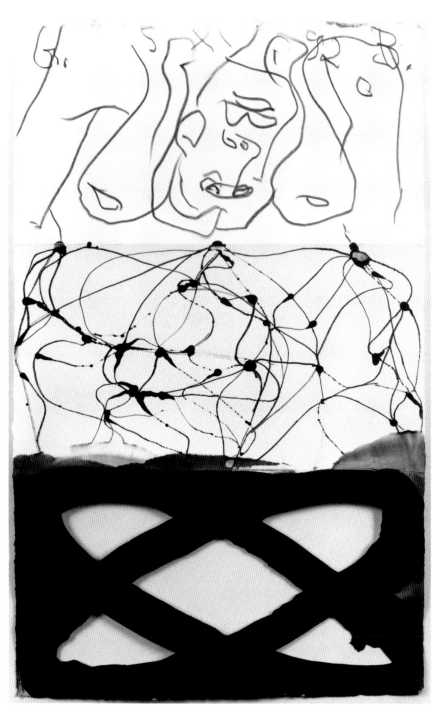

Georg Baselitz, Brice Marden, and Mary Heilmann, 1993

THE LITTLE VENUS OF ESKIMOS

"You just go on your nerve"
– Frank O' Hara

\mathscr{I} remember reading as a child that there once lived in
India people called Sciapodes. They had a single large foot
on which they moved with great speed and which they also
employed as an umbrella against the burning sun. The rest
of their marvelous lives were up to the reader to imagine.
The book was full of such creatures. I kept turning its
pages, reading the brief descriptions and carefully examin-
ing the drawings. There was Cerberus, the dog with three
heads; the Centaur; the Chinese Dragon; the Manticora,
which had the face of a man, body of a lion, and a tail like
the sting of a scorpion; and many other wonders. They
resembled, I realized years later, the creations of *cadavre
exquis*, the surrealist game of chance. I was also reminded
of Max Ernst's surrealist collage novels, where bird wings
sprout from people's backs and rooster-headed men carry
off naked women.

The history of these fabulous beings is dateless. They
are found in the oldest mythologies and in all cultures.
Their origins vary. Some are very probably symbolic repre-
sentations of theological ideas by long forgotten sects
and alchemist schools for whom the marriage of opposite
elements was the guiding idea. Others, I'd like to believe,
are the products of sheer fantasy, the liar's art, and our
fascination with the grotesque image of the body. In both
instances, they are the earliest examples of the collage
aesthetic. Mythological zoos testify to our curiosity in the
outcome of the sexual embrace of different species. They
are the earliest examples of the collaboration of dream and
intellect for the sake of putting appearances into doubt.

Were these visual oxymorons of ancient bestiaries first
imagined and then drawn, or was it the other way around?
Did one start drawing a head, and the hand took off on its
own, as it does in automatic writing? It's possible, although
I don't have a lot of faith in automatic writing, with its aping
of mediums and their trances. All my attempts at opening
the floodgates of my psyche were unimpressive. "You need
a certain state of vacancy for the marvelous to condescend
to visit you," said Benjamin Péret. Very well and thanks
for the advice, but I have my doubts. The reputation of
the unconscious as the endless source of poetry is overrated.
The first rule for a poet must be: cheat on your unconscious
and your dreams.

*

It was Octavio Paz, I believe, who told me the story about
going to visit André Breton in Paris after World War II,
being admitted and told to wait because the poet was
engaged. Indeed, he could see, from the living room where
he was seated, Breton furiously writing in his study. After a
while he came out, they greeted each other, and set out to
have lunch in a nearby restaurant.
"What were you working on, *maître?*" Paz inquired as they
were strolling to their destination.
"I was dong some automatic writing," Breton replied.
"But," Paz exclaimed in astonishment, "I saw you erase
repeatedly!"
"It wasn't automatic enough," Breton assured the young poet.

I must admit to being shocked, too, when I heard the story.
I thought it was only me who did that. There have always
been two opposite and contradictory approaches to chance
operations. In the first, one devises systems to take words
at random out of a dictionary, or writes poems with scissors,
old newspapers, and paste. The words found in either
manner are not tampered with. The poem is truly the prod-
uct of blind chance. All mechanical chance operations,
from dada's taking words out of a hat to the compositions
of John Cage and the poems of Jackson Mac Low, work
something like that. There is no cheating. These people
are as honest and as scrupulous as the practitioners of photo-

realism. I mean, they are both suspicious of the imagination. They handle chance with a Buddhist disinterestedness of mind and do not allow it to be contaminated by the impurities of desire.

My entire practice, on the other hand, consists of submitting to chance only to cheat on it. I agree with Vincent Huidobro, who said long ago: "Chance is fine when you're dealt five aces or at least four queens. Otherwise, forget it." I, for example, may pull a book from my bookshelf, open it anywhere, and take out a word or phrase. Then, to find another bit of language to go along with my first, I may grab a second book or peek into one of my notebooks and get something like this:

> he rips some papers
> forest
> whispers
> telephone book
> a child's heart
> the mouse has a nest
> concert piano
> lost innocence
> my mother's mourning dress

Once, however, I have the words on the page, I let them play off each other. In the house of correction called sense, where language and art serve their sentence, the words are making whoopee.

> *Innocence*
> Someone rips a telephone book in half.
> The mouse has a nest in a concert piano
>
> In a forest of whispers,
> A child's heart,
> The mother's mourning dress.

This is more interesting. I'm beginning to feel that there are real possibilities here. To see what comes next, I'll call on chance for help again. My premise in this activity is that the poet finds poetry in what came by accident. It's a complete revision of what we usually mean by creativity.

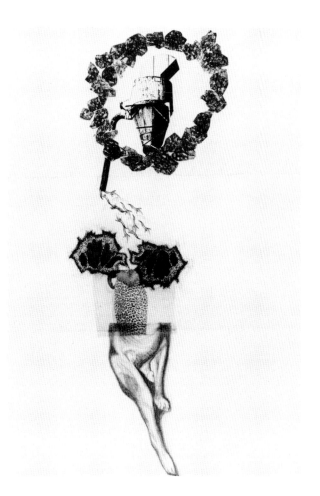

Joanne Brockley, Meg Belichick and Peter Cain, 1992

Twenty years ago, James Tate and I collaborated on some poems in the following manner. We'd take a word or a phrase and then we'd turn ourselves into a "pinball machine of associations," as Paul Auster would say. For example, the word "match" and the word "jail" would become "matchstick jail." At some point we'd stop and see what we have. We'd even do a bit of literary analysis. We'd revise, free associate again, and watch an unknown poem begin to take shape. At moments we felt like we were one person; at other moments, one of us was the inspired poet and the other the cold-blooded critic.

Russell Edson, who with James Tate and John Ashbery, is one of our greatest believers in lucky finds, says: "This kind

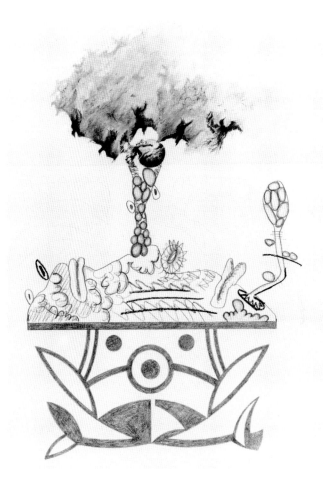

of creation needs to be done as rapidly as possible. Any
hesitation causes it to lose its believability, its special reality."
I have the same experience. One doesn't come up with
phrases like Tate's "the wheelchair butterfly" or Bill Knott's
"razorblade choir" by way of a leisurely Cartesian meditation.
They are as much of a surprise to the poet as they
will be to the future reader.

Jack Barth, Carroll
Dunham, and
Trevor Winkfield,
1993

<center>*</center>

I open myself to chance in order to invite the unknown.
I'm not sure whether it's fate or chance that dogs me
around, but something does. I'm like a reader of tea
leaves in that store on the corner. In Madame Esmeralda's
metaphysics, there is a recognition scene, too. Clairvoyants

believe that there are lucky days, moments when one's divinatory abilities are especially acute. Today, one says to oneself, I'm the waking dream, the source of the magical river! I see the hand that guides fate. The miraculous thing is that the tea leaves and the poem always end up by resembling me. Here is a near-portrait, the story of my life, and I've no idea how they got there.

If you worship in the Church of Art with a Message, stay away. Chance operations make trouble, promote ambiguity, spit on dogmatism of any kind. Everything from our ideas of identity to our ideas of cause and effect are cheerfully undermined. Surrealist games are the greatest blasphemy yet conceived by the arts against the arts. In them, the disordering of the senses is given ontological status. Chance brings a funhouse mirror to reality. They used to burn people at the stake for far less.

There has never been a poet who didn't believe in a stroke of luck. What is an occasional poem but a quick convergence of unforeseen bits of language? That's what Catullus and Frank O'Hara are all about. Only literary critics do not know that poems mostly write themselves. Metaphors and similes owe everything to chance. A poet cannot will a memorable comparison. These things just pop into somebody's head. In the past one thanked the gods or the Muse for it, but all along chance has been passing out freebies. Charles Sanders Peirce claimed that only by granting the occurrence of chance events can one account for diversity of the universe. The same is true of art and literature.

How does one recognize that blind accident has given one poetry? This is what puzzles me. What is it that guides the eye or the ear to accept what appears at first ugly or nonsensical? One says to oneself many times while writing, what I have here I do not understand at all, but I'm going to keep it no matter what.

> Painter of doll faces
> Here's a window where my soul
> Used to peek out at night
> At the quickly improvised gallows

If there's no such thing as an aesthetic sense, how does one pick and choose among the various products of chance and decide some are worthless and some are not? Obviously, the history of modern art and literature has accustomed the eye and ear to the unexpected. We are happy, or so we believe, to reorient our vision, to accept any outrage. Is it still our old fascination with freak shows that drives us, or are formal aesthetic considerations just as important?

No doubt both. Successful chance operations stress the ambiguous origin and complex nature of any work of art or literature. The art object is always a collaboration of will and chance, but like your sense of humor, it eludes analysis. There has never been an adequate definition of why something is funny or why something is beautiful, and yet we often laugh and make poems and paintings that reassemble reality in new and unpredictably pleasing ways.

*

What shocks more in the end, what we see or what we hear? Is the ear more avant-garde or the eye? Surrealist art has found more admirers than surrealist poetry, so it must be the eye. It's the new image that both painters and poets have dreamed of in this century, an image that would be ahead of our ideas and our desires, an image magnificent in its shock and its irreverence. Perhaps some new Temptation of Saint Anthony in which the holy martyr praying in the desert would be surrounded by the rioting menagerie of Exquisite Corpses instead of traditional demons?

Surrealists intuited that the creation of the world is not yet finished. The Chaos spoken of in ancient creation myths has not said its last word. Chance continues to be one of the manifestations of cosmic mystery. The other one is mathematics. We are crucified in awe between freedom and necessity. The future is the forever unfolding game of *cadavre exquis*.

In the meantime, like the song says,
"I've got my mojo working." —C.S.

Mary Ann Caws

EXQUISITE ESSENTIALS

For Jacqueline Lamba (1910-1993)

Toujours pour la première fois
Always for the first time[1]

\mathcal{L}ook, what an odd contraption. An inverted hot-air
balloon comprises the head, a teacup forms one ear, two
birds the other. The torso, a cylinder or magnetic coil
held between two planes, is tentatively poised on dainty
legs. This curious figure, hovering weightless upon a pair
of scales, was made during one round of the surrealist game
cadavre exquis by artist Yves Tanguy, surrealist founder and
theoretician André Breton, and Breton's then wife, artist
Jacqueline Lamba.

Cadavre exquis derives in part from a game the dadas played
called Little Papers, in which players composed chance
poems from randomly chosen words. As proof of the
value of automatism and chance, the game had to be taken
seriously. Here are the rules, if you are playing in French,
as those surrealists were. The first player takes a piece of
paper, writes a noun upon it, and folds it so that the second
player cannot see what is written; that person then writes
an adjective, folds it over, and passes it to the third person,
who adds a verb and passes it on. The fourth player adds
a noun, folds the paper over, and the fifth player adds
an adjective and unfolds the paper to read the sentence.
(In English, of course, the order is simply changed to have
the adjective come before the noun.)

Jacqueline Lamba,
Yves Tanguy, and
André Breton,
Cadavre Exquis, 1938

33

The same procedure is followed with the visual game—the *cadavre exquis*. In both versions of the game, the final result was believed to be greater than what the players would have otherwise achieved separately or together in conscious collaboration. The point of the play was both collective and automatic: the unleashing of the marvelous or the irrational in a group, with each player energizing the others toward the final corporeal surprise. Combining communality, performance, and personality, these works took the measure of the collective mind.

There was a time when the surrealists were dadas. Tristan Tzara, as surely the Papa-Dada from 1916–1922 as André Breton was the Pope of Surrealism from then on, had once recommended his own system for liberating one's pent-up unconscious poetic forces. The players ("writers") would simply cut out several expressions from a newspaper and drop them in a hat. Each person selected one at random and arranged the phrases in the order in which they were found. These findings, or *trouvailles*, were witnesses to the "marvelous" in everyday life to which all the dadas and surrealists were addicted, from Duchamp to Breton. The found text, said Tzara to the players, his tongue firmly (where it usually was) in his cheek, will resemble you.

The first Exquisite Corpse, as the story goes, was born in late 1925, in the house of Marcel Duhamel, situated at 54 rue du Château in Paris. Duhamel, the poet Jacques Prévert, and Tanguy sat down to play the game. "You just put down anything," says Prévert, and it worked.[2] (Of course, everyone has since admitted that only the best results were kept.) The first sufficiently striking sentence that emerged in the verbal experimentation read: *"le cadavre exquis boira le vin nouveau"*—"the Exquisite Corpse will drink the new wine."

There they were, first the dadas and then the surrealists, all huddled around, waiting, watching whatever experiment was on the boards or the table. They gathered in the equivalent of the surrealist moment of grace, the *état d'attente*

Josie Robertson, Katharine Kuharic, and Jean-Philippe Antoine, 1991

35

or state of expectation. Salvador Dalí, later despised by
the surrealists, who called him Salvador Dollars, gives
a vivid picture of one of these small groups, in willing
collaboration, playing a game similar to *cadavre exquis*.

> All night long a few surrealists would gather
> round the big table used for experiments, their
> eyes protected and masked by thin though
> opaque mechanical slats on which the blinding
> curve for the convulsive graphs would appear
> intermittently in fleeting luminous signals, a
> delicate nickel apparatus like an astrolabe being
> fixed to their necks and fitted with animal
> membranes to record by interpenetration the
> apparition of each fresh poetic streak....
> Meanwhile their friends, holding their breath
> and biting their lower lips in concentrated
> attention, would lean over the recording
> apparatus and with dilated pupils await the
> expected but unknown movement, sentence,
> or image.[3]

It was a joyous affair. "André shrieked with joy," says his
wife, "seeing immediately one of those sources or natural
cascades of inspiration he loved to find. Suddenly, every-
thing was unleashed."[4] Immediately, suddenly, rapidly,
right now, look: the transcription was not just automatic,
it had to be quick. The instantaneous was able to abolish
a mental censorship that would have been the death of the
lively corpse. Breton himself would comment at length
about rhythms and their importance. When he and
Philippe Soupault wrote their famous *Poisson soluble*
together—*Soluble Fish*, like the man "soluble in his
thought"—they carefully recorded the rate at which each
wrote. Verbal inspiration could be relied on, at least in
the beginning. Longer texts proved problematic, even in
theory. Conscious judgement could sneak into a sequence
of sentences, so transitions were not without their dangers.
The advantage of the single-sentence collective corpse
was its spontaneity.

Breton insisted on the ability of images to procure a desired emotion, and also upon the fact that anyone who wanted to share in it was free to. The poetic here is a matter of collective interpretation. Freedom, as construed in this game and all it entails, is essential. The moral does not enter into the poetic, which is the point of the essentially joyous experimentation with words, images, cognition, and recognition: any emotion at all.

<p style="text-align:center">*</p>

Surrealist techniques aimed to liberate the unconscious from its rational restrictions, as can be seen in surrealist works from Max Ernst's frottages or rubbings and Hans Arp's tearing of papers to the hypnotic sleep-writings and conversations practiced by surrealists such as Robert Desnos. What might have seemed, to the outside eye, disorder proved instead to reveal some remarkable hidden ideas and longings within a visual and especially dynamic form.

André Breton, founder and chief spokesman of the surrealist movement, wanted, at all costs, to avoid a deadly and stulti-fying static world, whose normality and ordinary balance would be taken as a virtue by rationalists, those beings diametrically (and forever) opposed to the lyric behavior of surrealists. His praise for "the art of madmen and of children" was undying.[5] The *cadavres exquis* have, at their very best, the feeling of both. Reason, says Breton, is sent on holiday to set the writing and drawing mechanism in free play, each enabling the other. But the holiday was serious; as Simone Collinet (André Breton's first wife) explained, this collective play was "a method of research, a means of exaltation and stimulation, a gold mine of find-ings, maybe even a drug."[6]

Caring not a fig for order, for how we fit in, for what we sound like and look like, the Exquisite Corpse disorients: it devalues the singular imagination. It is antiestablishment in the crudest sense; it exults in the antisentimental, the anti-individual, the antilogical. It is in no way Apollonian, being strictly Dionysian in impulse. But it is about

relations, about the mind and the object, the mind and chance, the mind and its ultimate possibility. No one single mind can grasp the relations set up, so arbitrarily, in principle, between this thing that I find and set down, and this next thing that the two of you are finding and setting down, separately. It is like the "sublime point" of surrealism, a spot on a mental mountain, where all the contraries impossibly meet—life and death, up and down, yes and no—about which Breton tells his small daughter, "It was never a question of establishing my dwelling on this point." As in *cadavre exquis*, you can look at the convergence in one of these bodies, verbal or visual, yet you could not live in it. As Breton goes on to explain, "It would, moreover, from then on, have ceased to be sublime and I should, myself, have ceased to be a person."[7]

*

These corpses, far from sublime, don't stand in the way of humanness. They don't look like anybody you've ever seen or wanted to, isn't that right? Sort of like the stuff of dreams. That this technique should have elicited such enthusiasm and even such passion, over such a long period, in so many diverse places and from so many diverse players, both poets and artists, is at least partially explained by its conjunction of highly charged elements. Converging in the gaming moment, and in its subsequent revelation, to produce a dazzle whose dynamics are equivalent to that of the surrealist image itself, these elements were deliberately chosen from fields as far apart as possible for maximum energetic force.

Against the pride of personal possession, the group-manufactured sentence or drawing gets greatest return from the simplest of sources, from the child's game, the found object, the fragment. "Words are not playing," Breton said, "they are making love." These communal gatherings had something of the erotic to them, no doubt about it. One of the most remarkable works in this exhibition (p. 12), made in the mid-twenties, composed by a relatively large cast,

including André Breton, Max Morise, Jeannette Tanguy, Pierre Naville, Benjamin Péret, Yves Tanguy, and Jacques Prévert shows an umbrella balanced on a trunk, doubtless closed upon some secret, above two rather mismatched legs with saucepans, their handles fluttering like so many feathers. The out-flying handles visually echo or rhyme the ribbons protruding from the legs. Where collective composition is the point, the idea of playing together makes an effective demonstration—always taken as miraculous—of the mental affinities among the three or four persons playing the game. In this, as in much of Breton's thinking and writing, he proves his own theory about surrealism being the prehensile tail of the romantic movement.

*

Surrealist objects of any kind were thought to be concrete realizations of our desire, like chemical precipitates. If Breton's "poem-objects" were, as their name indicates, a combination of the verbal and the visual, so too were the Exquisite Corpses composites—drawn, quartered, and titled by the same folded paper procedure. That each participant supplied only a part and yet that the tripled or quadrupled or even quintupled imagination should have led to a whole more intense in its effect than any one player could have imagined was proof of the continuing "marvelous" of the discovery. Here the automatic met the erotic, for the partial creations merged in an explicit substantiation of group desire for the body entire. Each part imagined refers inevitably back to the whole. The collective faith and the automatic individual gesture are linked in the game. This is just the way it is, says the collective image: take me on my own terms. Each time, the unfolded body was greeted, to the amazement of the participants, as something familiar. Like a group dream, like a fantasy owned up to, by more than one possessor and possessed, this collective creation spoke loudly for more than itself.

Caraco est une belle garce: paresseuse comme un loir et gantée de verre pour ne rien faire, elle enfile des perles avec les dindons de la farce.
Caraco is a beautiful whore: lazy like a dormouse and gloved in glass, so that she does nothing but string pearls with a farce of geese.
—cadavre exquis

39

Here, together, situating ourselves on the very edge of the postmodern gesture, with its revolutionary reliance on the fragment and the part, we can look now, all of us, towards the whole of this art/act, at once behind us and still ongoing, determined never to lose that sense of play which demonstrates as it renews our continual faith in and hunger for the surrealist unexpected. —M.C.

Notes

1. From the poem "Always for the First Time," in *Poems of André Breton*, Jean-Pierre Cauvin and Mary Ann Caws, trans., (Austin: University of Texas Press, 1982), p. 109.

2. Simone Collinet, describing the Exquisite Corpse game in André Breton, *Le Cadavre Exquis: son exaltation* (Milan: Chez Arturo Schwartz, 1975), p. 30.

3. Salvador Dalí, quoted in Lucy Lippard, ed., *Surrealists on Art* (Englewood Cliffs, New York: Prectice-Hall, 1970), p. 88.

4. Simone Collinet, quoted in Breton, *Le Cadavre Exquis*, p. 30.

5. See Breton's essay "The art of Madmen and of Children," in *La Clé des champs* (Paris: Editions du Sagittaire, 1953). See also André Breton, *Mad Love* (Lincoln: University of Nebraska Press, 1987).

6. Collinet, quoted in Breton, *Le Cadavre Exquis*, p. 30.

7. André Breton, *Mad Love*, p. 114.

Dorthea Tanning, Ray Smith, and Francesco Clemente, 1993

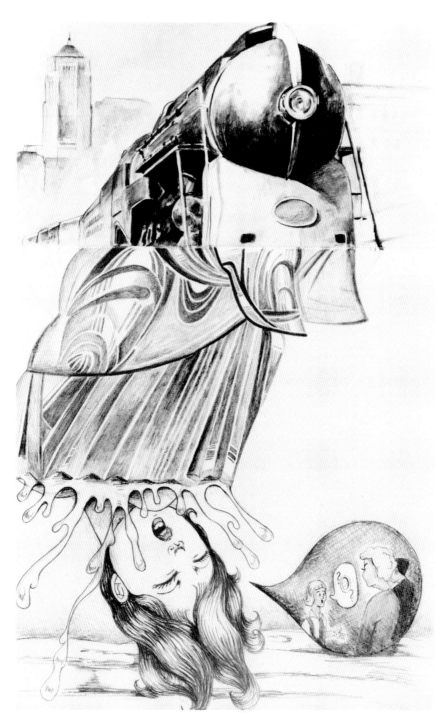

Lawrence Gipe, Emily Cheng, and David Humphrey, 1992

APRES EXQUIS

Walter Benjamin, a connoisseur of radical montage, wrote, "The father of surrealism was dada; its mother was an arcade."[1] Seen in this light the *cadavre exquis*, surrealism's abject offspring, is a visual department store disgorged of its goods, an assembly line of absurd—at times, sublime— expressions. So how, one may well ask, do we read it?

One heeds in the interpretation of original *cadavres exquis* drawings a caution against too singular a reading, a caution which the works themselves support. With only a few important exceptions, historic *cadavres exquis* have been exhibited as secondary works, treated within the larger context of surrealist games and automatism.[2] Much has been written on technique. Famous sessions have been documented, but there is very little in print about individual *cadavres*.[3] For the most part, these works exist as uninter- preted records, novel apparitions of *point sublime*, that spot on the distant horizon where everything—rational and irrational, conscious and unconscious, abstract and concrete—converge.

One of the first guides to this surrealist arcadia was Julien Levy's book *Surrealism*, published in 1936 by the legen- dary Black Sun Press. Bound with jacket covers by Joseph Cornell, and printed on a rainbow of colored paper, this book sings like a synthetic scrapbook of surrealist precepts and personages. It contains, under headings such as CINEMA, FETICHISM, and BEHAVIOR, everything from the screenplay for the Luis Buñuel/Salvador Dalí film,

Un Chien Andalou, to a passage from Freud's *The Interpretation of Dreams*, from pictures of work by Max Ernst to poems by Paul Eluard. For surveying the aftermath of "The Return of the *Cadavre Exquis*," Levy's approach seems a ready model. Allow the fragments to take issue, to form, and fall as they will, although today these fragments do not coalesce at *point sublime*.

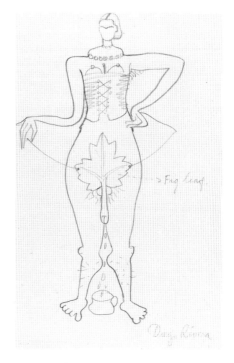

Lucienne Bloch met Frida Kahlo and Diego Rivera late in the year 1931 when the couple came to New York for a retrospective exhibition of Rivera's work at The Museum of Modern Art. They lived at the Barbizon-Plaza Hotel; the hotel's stationery appears in the three *cadavres exquis* in this exhibition by Kahlo and Bloch.

Frida Kahlo and Lucienne Bloch, *Exquisite Corpse (Diego Rivera)*, circa 1932

Frida Kahlo and Lucienne Bloch (in alternating order), *Exquisite Corpse (Frida Kahlo)*, circa 1932

Surrealism

In 1916 Guillaume Apollinaire named a poetic spirit adrift
throughout the ages "surrealism."[4] By its first historical
account, recorded in Levy's book, surrealism claimed
amongst its forebears the Marquis de Sade "in sadism,"
Edgar Allen Poe "in adventure," Rimbaud "in life and
elsewhere."[5] Others include the satiric illustrator de
Granville, the symbolist writer Isidore Ducasse (a.k.a.,
compte de Lautréamont), the photographer of Paris
Atget. Those ordained: the Marx Brothers, and Frida
Kahlo, who coyly commented upon her own induction,
"I never knew I was a surrealist till André Breton came to
Mexico and told me I was."[6] Working outside Breton's
jurisprudence, David Lynch's ant's-eye-view, Angela
Carter's violet pornography, Bob Dylan's tombstone blues,
and virtual reality could also be called surrealist.

As called forth by "The Return of the *Cadavre Exquis*,"
surrealism's essence, a montage of irresolute fragments,
appears impossible to contain. Teased by Linda Herritt,
surrealism's coif, stiff as shellacked drapery, tumbles down
in the luxuriant fall of Millie Wilson's hairpiece. Its head is
buried alive by Jim Shaw under a mound of delicately ren-
dered octopi. (The image of an octopus recurs as legs in a
photogram by Kunie Sugiura.) Drawn by Lawrence Gipe
(p. 42), the face of a freight train comes to light, only to
be extinguished by Lawrence Weiner, who attributes to
surrealism no features at all. Sporting a dirty velvet cum-
merbund, courtesy Maurizio Pellegrin, with Kavin Buck's
body of text, surrealism's sex is indeterminate, but—as Don
Ed Hardy would have it—voracious, or, even—according
to John Wesley (p. 49)—orgiastic. Standing back for
the panoramic view, surrealism's style is both elegantly
calligraphic and compulsively blunt. Language colloquial.
Surrealism is humorous, certainly sports a tattoo, may have
served time in prison, frequently stalks on animal legs. –*I.S.*

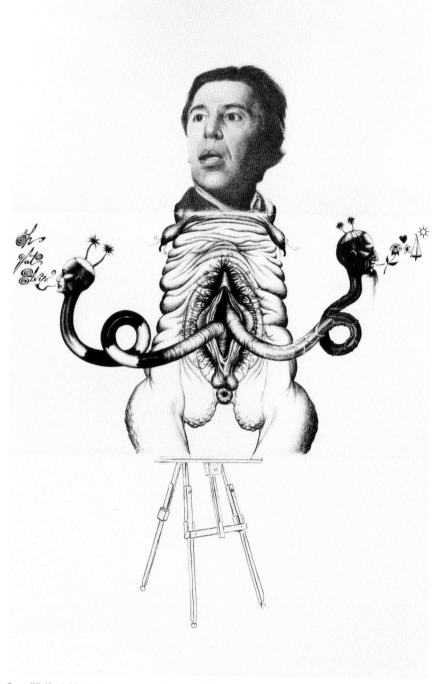

Steve Wolfe, Ashley Bickerton, and Jan Hashey, 1993

Surrealisms

Author of the movement's polemics, André Breton was
surrealism's inspired leader and tyrannical prince. It's ironic
and indicative of surrealist spirit that Breton, who attempt-
ed to encode it, define it, even determine its politics, was
ultimately eluded by it. Enervated by Salvador Dalí's
remarkable imagery and exasperated by his behavior,
Breton dispelled Dalí from the ranks of the surrealists in
1934. And yet in the popular mind it's Dalí who is most
closely linked with historic surrealism. In retrospect and
of late, Georges Bataille, now seen as surrealism's critical
author, has similarly displaced Breton.[7]

Whereas Breton's surrealism distills itself into objects—a
bowler hat, a biscuit, a woman's glove—Bataille envisions it
as an image of diffusion, an excess of energy that obscures
containment. He called this the "informe," and ascribed
it with the "job" of rendering the formed object, idea,
emotion, or sign into a state of formlessness.

> *Formless* is thus not merely an adjective with
> such and such a meaning but a term for lowering
> status with its implied requirements that
> everything have form. Whatever it (formless)
> designates lacks entitlement in every sense
> and is crushed on the spot, like a spider or
> an earthworm.[8]

The surrealist movement governed by Breton tends to
reside resonantly in particulars—clocks, dolls, and found
objects—which are themselves dated in appearance.
However, as conjured by Bataille, surrealism is transgres-
sive. It exceeds the parameters of time, the strictures of
space, and is thereby elusive.

Both surrealisms have come into play during the course of
this game. Sometimes as direct bodily evocations. After
Man Ray's famous photographic portrait comes a drawing
by Steve Wolfe of André Breton's head. Cindy Bernard
uses the text of Bataille's "Big Toe," which declares this
appendage to be the most human part of the body.

Other times, these two surrealists appear as oblique points of reference: Bretonian collage, displacement, found objects are drawn together with Bataille's tattoos, scars, animism, diaspora, and pictures of spiritual ecstasy. The former is captured in a drawing, rich with nostalgia, by Doug Ashford, Ruth Libermann and Anita Madeira, which starts with a poem and ends with collage on little cat feet. Elements of the latter surrealism are lodged in the hectic, scribbled drawing which hovers over an image of mannequin legs akimbo in the *cadavre* by Alan Turner, Carroll Dunham, and Laurie Simmons.

At its most poetic, this game remains as Breton intended it—and Bataille may have played it—with critical spirits expelled on holiday, an informal evocation of surreal possibilities. It's the critical burn in Bataille's look which transforms Breton's game of *cadavre exquis* into a postmodern possibility. —I.S.

Games

Play might be considered the discipline of this century. Voicing every thought that came to mind, Sigmund Freud played by the rules of free-association to enter into the realm of his own unconscious and thereby formulate a modern picture of the mind. Likening their exhilarating progress to mountain climbing and aviation, Georges Braque and Pablo Picasso worked closely and competitively to invent Cubism, opening pictorial space up to radical speculation and abstraction. Albert Einstein called it relativity. Accomplishing a similar feat in the field of linguistics, Ferdinand de Saussure—himself an avid anagram player—re-envisioned the structure of language after the game of chess by equating words with game pieces, each dependent on the play of context for meanings mutable and strategic. For Foucault, this notion of language as an object of knowledge open to historical change and arbitrary deformation marks the inception of the modern era.

Consider the knight in chess. Is the piece by itself an element of the game? Certainly not. For as a material object separated from its square on the board and the other conditions of play, it is of no significance for the player. It becomes a real, concrete element only when it takes on or becomes identified with its value in the game.
–Ferdinand de Saussure, *Course in General Linguistics* (1906-11)

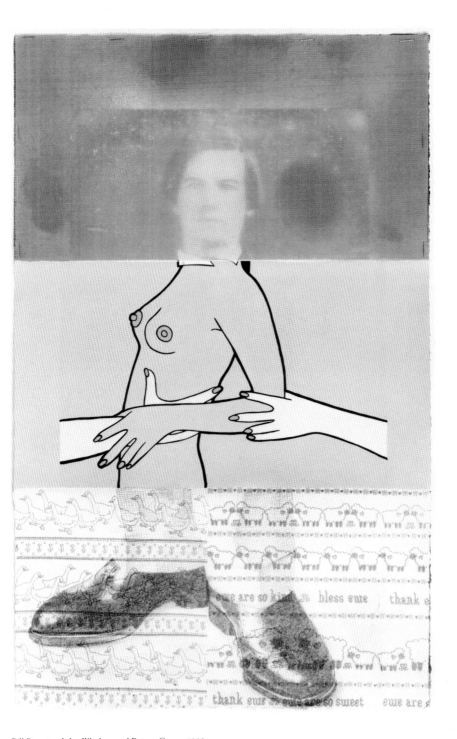

Bill Barrette, John Wesley, and Rainer Gross, 1992

49

Play is the essence of abstract thinking and creative inven-
tion, a form of behavior with no anticipated goals or results
other than pleasure itself. In the wild, young animals frisk
about as a way of learning how to behave. For almost
the exact opposite reason, we humans continue to romp
as adults in order to refresh our minds and bodies from
the restrictions of routine approaches and activities. As an
alternative to the conduct that led a world to war, dada
gambled on misbehavior in order to transgress all etiquette
and establish a new cultural (dis)order.

Applying themselves more systematically to this project,
the surrealists adopted games as a form of experimentation.
They played hard at scores of word and picture games in
order to escape what they knew and discover what could
be imagined.[9] Making art in this vein, Alberto Giacometti
constructed his series of sculptural game boards in the thir-
ties. Max Ernst's late sculptures are iconic chessboard fig-
ures. Disciples of the European avant-garde, the American
abstract expressionists also dutifully played surrealist games.

Not exactly a team player, Marcel Duchamp allegedly
abandoned art—with all its knowable forms—for chess. It
is interesting to note that in formulating a theory of games,
the mathematician John Neumann discounted chess. As
it relies on tactics that are short term "if " actions, with cal-
culable results, it doesn't resemble those real games we con-
stantly play in life, which are based on strategies or more
open-ended "what-if" abstractions.[10] Though very few peo-
ple play chess these days, such enigmatic strategies have
endured. Aleatoric, what-if abstractions structured art of
the sixties and seventies, making it spontaneous and
lifelike. Daring silence, John Cage invited chance to play
in the midst of his piano performances. Jean Tingley's
self-destructive sculptures played themselves to death.
Games such as these moved art into real time and space.

As so evidently portrayed here, the artworld's facture has
grown increasingly dispersed, its community decentralized

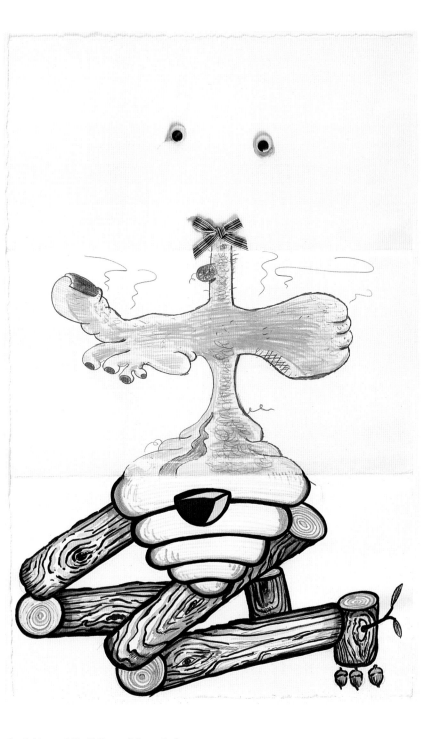

Linda Herritt, Mike Kelley, and Cassandra Lozano, 1992

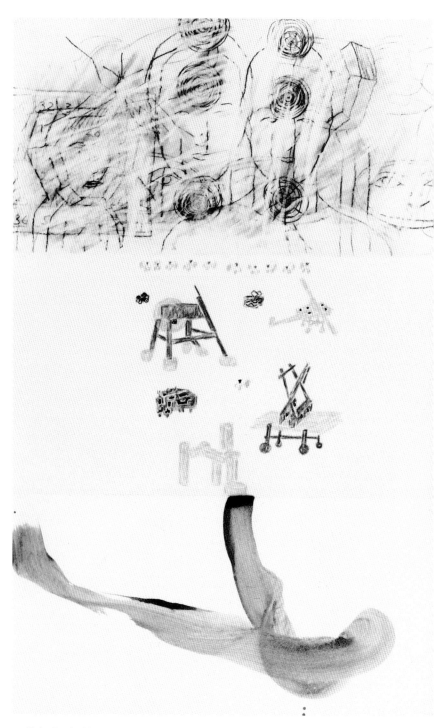

Philip Smith, Chris MacDonald, and James Nares, 1992

and insular. As we so well discovered during the process of this project, ferreting artists out of their studios all over the world, there are no café-headquarters. In turn the nature of play has changed. Presaged by such (surrealist) examples as Claude Cahun's gender-bending photographs and Leonor Fini's performance-art approach to life, these games seem based more on role-playing and autobiography than on movements and conquest. The big games are now, in fact, small ones, inspired by those private (often childish) forms of amusement one tends to pursue alone, like dress-up, dolls, and make-believe. Forfeiting the utopian, or merely group-minded, aspects of earlier pursuits, players today scrimmage, not by prescribed rules, but according to personal whim and individual preference.

> L'huitre du sénégal mangera le pain tricolore.
> The Senegalese oyster will eat the tricolor bread.
> –cadavre exquis

So why, less than ten years short of the new millennium, do we reenact this early twentieth-century game? In retrospect of "The Return of the *Cadavre Exquis*," experimental intentions come forward, but initially we played in pious keeping with orthodox surrealism. Because it's fun. —*I.S.*

> If there is one activity in Surrealism which has most invited the derision of imbeciles, it is our playing of games.... Although as a defensive measure we sometimes described such activity as "experimental" we were looking to it primarily for entertainment, and those rewarding discoveries it yielded in relation to knowledge only came later.
> –André Breton, 1954.[11]

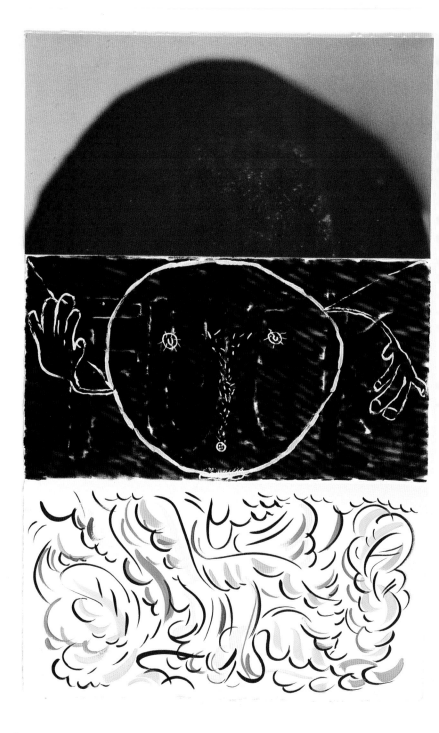

Jeanne Dunning, Johnny Pixchure, and Betsy Friedman, 1992-93

Christian Marclay, Olivier Mosset, and Alix Lambert, 1993

Collaboration

"All our collaborators must be handsome
so we can publish their portraits."
–René Magritte[12]

As a joint venture, collaboration defies logic: the whole is
not equal to the sum of its parts. The total picture stands to
topple over if the *cadavre exquis* is all earrings or individual
organs fail to communicate. Rather, collaboration is a
dialectical process. What is shared counts as much as that
which has been withheld. The creative outcome of a
successful collaboration is a new work, independent of
any single contribution. In a collaboration by Christian
Marclay, Olivier Mosset, and Alix Lambert, a pair of sutured
lips, two green stripes, and a pair of legs cemented into
one clay foot yeilds an image of thwarted expression,
an evocation of censorship not one of its parts belie (p. 55).

So good-natured by name, collaboration is not entirely
generous in spirit.[13] Like Lex Luther, it calls for the death
of the artist-superman. Listening for the collective voice,
collaboration reproduces the interpretive and communica-
tive aspects of art at the very level of its creation. Authen-
ticity also takes a flying leap. Trespassing time and author-
ship, Marcel Duchamp drew a moustache on the *Mona
Lisa*, making Leonardo da Vinci an unwitting accomplice
to this collaborative work of art. Here we find Aubrey
Beardsley, Constantin Brancusi, Gustave Courbet, Ezra
Pound, an unknown Rajistani artist as well as Duchamp
himself, among the many drawn into cahoots with the
creators of contemporary *cadavres exquis*.

Bypassing the author can create quite a snarl. The challenge
in collaboration is striking that delicate balance between
retaining commitment and relinquishing control. Ironically,
the mechanism which seems to keep collaboration healthy
is competition. It is, in part, this self-conscious measure
that accounts for the metamorphosis of the surrealist
cadavres exquis from the pure noodlings that first appeared
in the October 1927 issue of *la Révolution surréaliste* into
the considerably more engaging works of art that these
collaborations eventually produced.[14] – *I.S.*

Collage

Collage was the surrealists' umbrella aesthetic, sheltering a diversity of practices, from painting and poetry to the *cadavre exquis*. As a collection of things jumbled and juxtaposed, collage captured the experience of an aimless wander through crowded city streets and desolate alley ways. But collage was not about getting lost. Rather, it was a practice that required the purposeful selection, arrangement, and affixing of images. Collage-making was about looking, about locating the dream-image in the everyday.

Although faithful in spirit to the principle of collage, the surrealists often bypassed the process of affixing images for the seamless effects achieved through photography, either in-camera or during the printing process. Compositions of trimmed snips of paper, whose cut edges openly displayed the marks of their making, were more expressive of the cacophony of dada. The surrealists, on the other hand, effectively subsumed collage within the technology of photography. As the given automatic eye, the camera offered a range of techniques through which an image could be altered, for example, by doubling, flipping, and solarizing the negative. While the dadaists were indifferent to the power of photography's apparent objectivity, the surrealists were seduced by the uncanny "realness" generated by the manipulated photograph.

> *La vapeur ailée séduit l'oiseau fermé a clé.* Winged steam seduces the locked up bird. *—cadavre exquis*

Relegated to the periphery, hands-on collage nonetheless remained a central and reigning principle of surrealist practice. It became integral to the popular surrealist diversion *cadavre exquis*. Early examples of the game, composed entirely of drawing, were superseded by more elaborate works augmented by the addition of bits of paper and ephemera clipped from magazines, catalogues, and photographs. *Cadavre exquis* was a curiosity to the surrealists precisely because it laid bare the workings of collage. In the preface to an exhibition catalogue of Max Ernst's photo collages, Breton described the process of making collage as "attaining two widely separate realities without departing from the realm of our experience, of bringing them together and drawing a spark from their contact."[15]

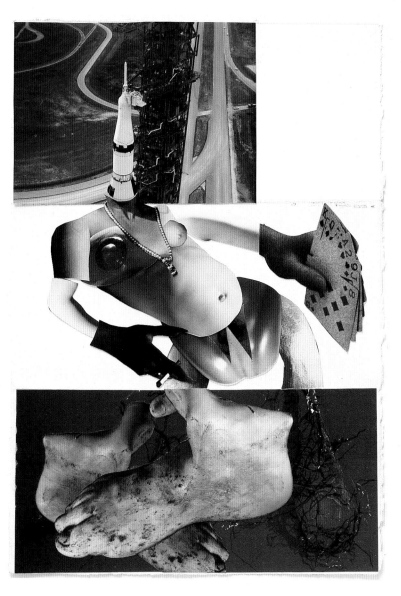

Julie Ault,
Cindy Sherman,
and Marc Tauss,
1992

Governed by chance, *cadavre exquis* playfully tested collage, fanning a gentle breeze to the match struck between images. Failures were as instructive and as pleasurable as successes.

Although not a technique commonly practiced in contemporary art, with this most recent round of *cadavre exquis*, collage has returned with a vengeance. To appreciate this

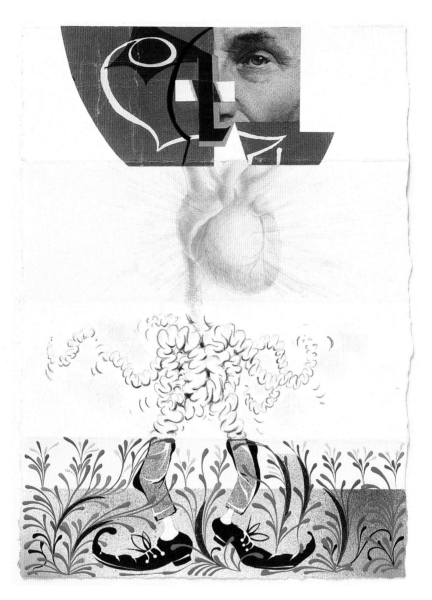

recourse to collage, it is helpful to consider *cadavre exquis'* origin as a word game. Read top to bottom, some of the drawings suggest the completion and closure of sentences. Such is the case with a drawing by Julie Ault, Cindy Sherman, and Marc Tauss, where the head, composed of a snapshot of a rocket, grows the body of a sinuous card-playing nude. To this body, ready to test the winds

Roy Dowell,
Tom Knechtel,
Megan Williams,
and Lari Pittman,
1992

of fate, is grafted a pair of ponderous go-nowhere feet. More often, the drawings are open-ended, as in the *cadavre* by Curtis Anderson, Joseph Nechvatal, and Rosemarie Trockel. Unified by a common media, —nineteenth-century scientific illustrations and maps—meaning here resides in the loose, rhyming association of the combined parts.

Interestingly, the technology of photography, the linchpin of the surrealist collage aesthetic, remains ever present in the contemporary game. Despite the advent of the computer, it is the technology of the camera that still dominates. Noted additions to the camera's repertoire include Xeroxes, both color and black and white. In fact, photocopies have overtaken the collaged clippings of the past— pieces of yellowed newspapers and magazines have given way to the mundane shadow of the Xerox image. But like the surrealists' embrace of photography, contemporary artists have been quick to make use of the potential of new technologies. In the drawing by the Critical Art Ensemble and Faith Wilding, a computer-generated head and torso is attached to collaged Xeroxes of repeating legs of armor. Processes common to surrealist photography, such as doubling, are now easily obtained through the use of the photocopier or the computer.

These contemporary works, however, rarely engage the everyday urban detritus that so fascinated the surrealists. Rather, present day *cadavres exquis* logically quote a range of styles characteristic of contemporary art. Today artists, caught playing a game which in all probability is not central to their practice, reach for a bit of the familiar. Still others responded by suspending their ususal practice. Many of the collage images they created are consciously dated, depicting outmoded machines and ghostlike grainy images from the past. Although the surrealists themselves were attracted to the forgotten and slightly out of fashion, contemporary artists have resorted to the past out of nostalgia. Whether seamless printouts or elbow-deep in clippings and glue, these images pay homage to the surrealist collage aesthetic. —*E.F.*

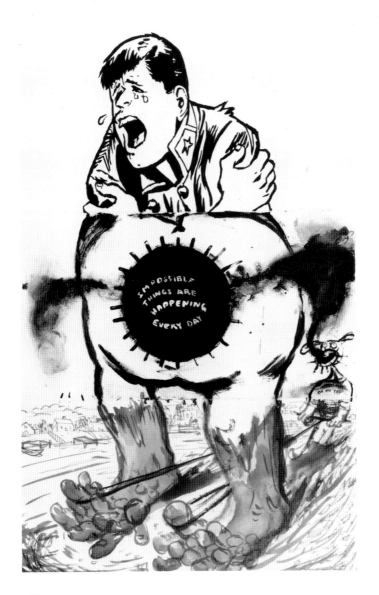

Grotesque

This is the other art history. Accompanied by Boschian
bagpipes, the Grotesque tracks a bloody footprint on the
road to Calvary, farts, eats off Archimbaldo's plate, burps,
drinks from Meret Oppenheim's tea cup, shits, dances
to Goya's capriccios, fucks, and sleeps to dreams of H.C.
Westermann's death ship. Shock and schism are its means,

Jim Shaw,
Sue Williams, and
Nicole Eisenman,
1992

Robin Tewes,
Megan Williams,
Gary Panter, and
Elliott Green,
1992-93

rupture its golden rule. The *cadavre exquis*, playing on all of the Grotesque's styles and strategies, is its Adonis, Venus, Marilyn, and Mickey.

Traditionally, the Grotesque appears heaped to either side of the Renaissance, in its overwrought aspirant—the Gothic—and aftermath—the Baroque. In style and content, both canons are highly visible here. With a medievalist's eye for the minute, Meg Belichick lifts images of potato

eyes and astral bodies for a torso made using found printer's
plates (p. 28). Her partner, Joanne Brockley, depicts the
sacred "temple of the mind" as a ruin of industrial architec-
ture. A horny male dog's haunches, drawn by Peter Cain,
completes this Boschian hybrid on a low, animalistic note.
Conflating human attributes and natural imagery is a device
of the gothic grotesque brought up to date by Hachivi
Edgar Heap of Birds, Claire Pentecost, and Eve Andrée

Mark Beyer,
Charles Burns,
and Peter Saul,
1992

63

Laramée. The tension between the head's explosive burst of color and the body's shackled cornstalk is poised—like Baba Yaga's house—on a giant pair of chicken legs, collaged from road maps. This image suggests that, at its best, nature's meeting with culture is an ambivalent one.

On the march with Brockley's automaton, a proliferation of *cadavres exquis* have been scrapped together by idolatrous engineers, who gleefully tinker with the machine of human anatomy. A drawing (p. 17) by Tony Oursler, James Casebere—both corroborating with mechanical modes of reproduction—and Charles Golden, recasts the model of classical perfection into a dehumanized pile of junk. Oursler's photograph of a television antennae mounted atop Casebere's image of a prison-cell toilet, set on Golden's biomorph of fabric flocking, portrays the body as a dubious technological wonder.

Matching the standards of postmodern culture, manufacture has taken on grotesque possibilities. Today, we all stand ready to be made into Exquisite Corpses. Pump it up. Suck it off. Tear it out. Reconstruct. Be all you can be, with the help of plastics, polymers, personal training, and, of course, the knife. Because the body is yours for the making. Constructing its identity cell by cell, the Exquisite Corpse realizes the ultimate, post-human fantasy of the flesh.

By giving way to grotesque displays of feeling, the corpse often upsets the equilibrium of emotions held in check by intellectual control. An agitated *cadavre* headed by Dottie Attie shouts and twists itself into a dramatic contrapposto, rendered by Mark Tansey, so that legs, by Steve Mendelson, seem to buckle under the impact. Conflating spiritual and bodily ecstacy, Eran Shakine's imprints of what appear to be the ephemeral contents of a mind swirl above collage contributions by James Elaine and Peter Gilmore of a martyred Saint Sebastian set above a miasma of organic matter. Emotionally acute, humanly critical, heaven-kissing and ground-hugging, the *cadavre exquis* cultivates its energy and imagery from outside the classic mainstream of art history to encompass the often otherwise inexplicable excesses and margins of existence.

Indeed, the grotesque corpse seems patterned in direct opposition to what Alberti, "the very founder of the theory of art, called *convenienza* or *conformità*." As Erwin Panofsky elaborated, "It would be absurd if Milo the athlete were to be represented with frail hips or Ganymede with limbs of a porter, and 'if the hands of Helen or Iphigeneia were aged and knotty.'"[16] This kind of physical comedy is the very meat of the *cadavre exquis*, just as mockery and satire present grotesque standards upon which the *cadavre* visibly thrives.

A traditional underpinning of painting, the cartoon has long since slid out on its own subversive mission. This might be simply comic—like the (tee-hee) he-man by underground comic artists, Mark Beyer and Charles Burns, with artist Peter Saul (p. 63). Or given more pointed caricature, a lampoon attack. In a *cadavre* (p. 62) concocted during the 1992 election campaign, Robin Tewes turns the Republican ticket (Misters Bush and Quayle) into a two-headed hydra, which Megan Williams endows with a whirling dervish of breasts. Gary Panter adds a fecund female body, which Elliott Green finally carries away on a pair of fishy wet feet. Laughing itself to hysterical tears, a *cadavre exquis* by Jim Shaw, Sue Williams, and Nicole Eisenman (p. 61) amplifies satire to a level of such ridiculous absurdity it verges on tragedy. Shaw's caricature of one of the kings of comedy, Jerry Lewis, emits a gaseous cloud drawn by Williams, which erupts over a field of destruction, landscaped by Eisenman.

L'amour mort
ornera le peuple.
Dead love will
adorn the people.
-cadavre exquis

Aching with the absurd, the Grotesque rips a hole in the sides of both convention and conventional response, through which the Exquisite Corpse easily passes. The corpse emerges on the other side as a transcendent being, whose body performs the rituals of life—including death— with vigorous regularity. *—I.S.*

Michael A. Tighe, Magdalena Bergheim, and Markus Döhne, 1992

Brett Reichman, Caitlin Mitchell-Dayton, and Peter Mitchell-Dayton, 1993

Sex

Bimorphic, polymorphic, hermapheditic, transsexual, homo-sexual, heterosexual—the *cadavre* is well-sexed. Perhaps it was simply the circumstances—a group creative effort—which started these juices flowing. Or else it was the prospect of surrealism—whose environs are the uninhibited unconscious mind—which elicted such licentious responses. Erotic energy courses through the collaboration of Bay Area artists, Brett Reichman, Caitlin Mitchell-Dayton and Peter Mitchell-Dayton (p. 67). A writhing bulb of gothic orna-ment, dripping with the oily patina of *temps perdu*, precipi-tates over the ample, bending, body of a late Marilyn, who, in white bikini, hands on hips, steps out of a bed shared with Betty at an orgy with other Archy comics, and even with just regular folks. Jughead's crown is on the bedpost.
—I.S.

Annette Lemieux,
Doug and Mike Starn,
and Timothy
Greenfield Sanders,
1992-93

The Corpse

Leveling humanity to its organic essentials, flesh, excrement, and organs prove all equal in the eyes of the coroner. A veritable morgue, "The Return of the *Cadavre Exquis*" details an autopsy of spilt blood and gore. In a *cadavre* by Chicago-

based artists Story Mann, Mary Lou Zelazny and Roderigo Avila, a portrait image of Abraham Lincoln is abolished to a slurry of guts and animal matter. In an adjacent operating room, Annette Lemieux performs an ink transfer upon an anatomical study of a head. This is joined to a photo-based image, by Doug and Mike Starn, of the body of Christ (certainly the most famous *cadavre exquis*), and blasphemously polished off by Timothy Greenfield-Sander's photographic fashion-plate.

There are also plenty of skeletons filling the ranks of the *cadavre exquis* and even a couple of x-rays. With death so near at hand, in both the name of the game and the images the game evoked, it is interesting to note that these spectors are patently metaphoric. The plagues inflicted by the AIDS virus and breast cancer, which constitute such an urgent component of today's cultural politics are—almost without exception—not named here. Such omission sheds light on the true nature of the *cadavre exquis* as a cathartic being, whose imagery and activity envelopes the particular into a raucous, transcendental body. —*I.S.*

Time and the Body

In the two years that have elapsed during the course of this game, the Exquisite Corpse marked time. Imagery based on the 1992 presidential election has already been mentioned in regards to the Grotesque. As if in response to the campaign button which read, "Elect Hillary's Husband," Bill Clinton does not appear here, though his wife does, in a collage contribution from Laura Fields. The national hoopla celebrating Christopher Columbus' arrival in America some five hundred years ago is quietly noted in the margins of a drawing by Moyo Coyatzin. (Marching backwards in history, this *cadavre's* torso by Douglas McClellan is a collage homage to Chairman Mao's colon.) "The Return of the *Cadavre Exquis*" also straddles the American Year of the Woman. Coincidentally her body is here—with and without precedent—one of surrealism's most graphic physical sites.

Piquant *femme-enfant*, man-eating sphinx—surrealism appears obsessed with fantastic images of women. Equating sexual and creative freedom, the surrealists subscribed wholeheartedly to the psychoanalytic concepts of eros and the libido as liberating life-forces. Arousing muses of (heterosexual) love, women stood as communicating vessels between men and the marvelous. Yet there was very little place accorded her in the movement's everyday membership, despite the participation of girlfriends and wives in *cadavre exquis*.[17]

Here, with the *cadavre's* return, women artists play in near equal numbers to men. Her body moves outside the bounds of a privileged male gaze, into the realm of a desiring or defiant female subject. Pantyhose legs contributed by Maureen Connor run to exhaustion and snarl with rebellious savagery. A simple slit cut through a torso-section by Siobhan Liddell turns up the acme fetish of castrating female. And there are abundant snippets from stories of "O," among them David Humphrey's girlish inquiry (p. 42). On the other hand, many depictions comply with a traditional feminine cast. Within the framework of *cadavre exquis*, these old parts were often handled to critical or comic effect. In a drawing by artists Bradley Rubenstein, Andrea Champlin, and Daniel Wasserman, a sinuously turning odalisque spins to a halt between her blandly bisexual head and jerry-rigged spring base.

*

Sex, difference, death, beauty, birth, and ugliness, are embodied by this grotesquely gorgeous being whose vertiginous flip-flops between male and female, animal and object, culture and nature, sensual and cerebral, confound readings based on reason. Leading well beyond the *point sublime*, or bypassing it entirely, there is no svelte *zeitgeist* lurking within "The Return of the *Cadavre Exquis*," though there are plenty of demons. Preying on the bugbears of an exclusive and synthetic approach to art, this inclusive body of work culminates in the antithesis of modernist principles. Collective and complicated, as opposed to singular and reductive, the *cadavre exquis* transgresses against the traditionally masculine construct of modernism and listens for a postmodern feminine ideal. —*I.S.*

Marilyn Minter, David Sandlin, and Sue Williams, 1993

1. Benjamin, quoted in Susan Buck-Morss, *The Dialectics of Seeing: Walter Benjamin and the Arcades Project* (Cambridge, Massachusetts: The MIT Press, 1991), p. 275.

2. The first exhibition of *cadavre exquis* was held in October 1927 at la Galerie surréaliste in Paris. Breton's account of the invention of the game appears as the catalogue text for the next important exhibition held at galerie La Dragonne, Paris, in October 1948. This text was reprinted for the occasion of an exhibition of historic *cadavres exquis* held at Galleria Schwartz in Milan in 1975. More recently, *cadavres exquis* were included in *Inventions Surréalistes: Collages, Frottages, Fumages, Cadavres Exquis* presented at Isidore Ducasse Fine Arts, New York, 1992.

3. For firsthand accounts see, André Breton, *Le cadavre exquis: son exaltation* (Milan: Chez Arturo Schwartz, 1975), and Cynthia Jaffee McCabe, *Artistic Collaboration in the Twentieth Century* (Washington, D.C.: Smithsonian Institution Press, 1984).

4. As William Rubin points out, it was William Lieberman who identified the origins of the word "surrealism" in Apollinaire's text for the program of Diaghilev's ballet, "Parade." See William Rubin, *Dada, Surrealism, and their Heritage* (New York: The Museum of Modern Art, 1968), p. 192.

5. See Julien Levy, *Surrealism* (New York: The Black Sun Press, 1936), p. 4.

6. Quoted in Bertram Wolfe, "Rise of Another Rivera," *Vogue*, November 1, 1938, p. 64.

7. For an exemplary discussion of Bataille's surrealism, see Rosalind Krauss, in *L'Amour Fou: Surrealism and Photography* (Washington, D.C.: The Corcoran Gallery of Art, 1985).

8. Georges Bataille, quoted in Denis Hollier, *Against Architecture: The Writings of Georges Bataille*, Betsy Wing, trans. (Cambridge, Massachusetts: The MIT Press, 1989), p. 30.

9. See Mel Gooding, ed., *Surrealist Games* (Boston: Shambhala Redstone Editions, 1993). This instructive, boxed compilation documents the history, rules, and results of surrealist games and collaborative techniques.

10. John von Neumann and Oskar Morgenstern, *A Theory of Play and Economic Behavior* (New York: John Wiley & Sons, 1964).

11. This excerpt is from Breton's only essay on games; quoted in Gooding, ed., *Surrealist Games*, p. 137.

12. René Magritte, "The Five Commandments," quoted in Lucy Lippard, ed., *Surrealists on Art* (New Jersey: Prentice-Hall, Inc., 1970), p. 155.

13. According to *Webster's New Collegiate Dictionary*, one definition of collaboration is "to cooperate with or willingly assist an enemy of one's country and esp. an occupying force."

14. Verbal and visual examples of *cadavres exquis* were first published anonymously in *la Révolution surréaliste*, October 1, 1927. Both appear intermittently throughout the text.

15. André Breton, quoted in Dawn Ades, *Photomontage* (New York: Thames & Hudson, 1976), p. 115.

16. Erwin Panofsky, *Meaning in the Visual Arts* (New York: Doubleday & Co., 1955), p. 190.

17. Breton, quoted in Whitney Chadwick, *Women Artists and the Surrealist Movement* (Boston: Little, Brown & Co., 1985), p. 27.

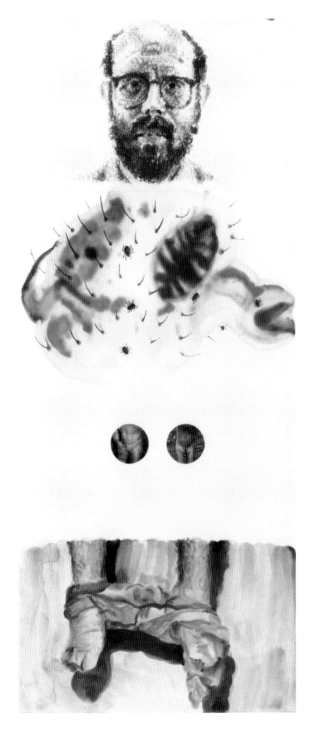

Chuck Close, Alexis Rockman, Mark Greenwold, and Dennis Kardon, 1992

73

Kay Divant
Eben Dodd
Markus Döhne
Antoni Domeneco
Cheryl Donegan
Bailey Doogan
Karni Dorell
Susanne Doremus
Mark Dorrance
Charles Dort III
Giovanna Dotta
Jim Doty
Maureen Dougherty
Brian Douglas
Ben Dover
Melody J.Doves
Bruce Dow
Roy Dowell
Julie Downing
Catherine Drabkin
Ostap Dragomoshchenko
Ric Pike Dragon
Peter Drake
Leonardo Drew
Scott Drnavitch
Yvette Drury Dubinsky
Renee DuBois
Dana Duff
Jeff Dugan
Marlene Dumas
Carroll Dunham
Michael Dunn
Jeanne Dunning
Debra Durst
Graham Durward
Nancy Dwyer
Jane Edelson
Mary Beth Edelson
Melvin Edwards
Lisa Ehrich
Brett Ehringer
Nicole Eisenman
Sue Eisler
James Elaine
Arturo Elizondo
Stephen Ellis
Eli Elysee
Lynn Emanuel
Elisabeth Ernst
Manel Esparbé Gasca
Eugenio Espinosa
Barbara Ess
Steven Evans
Sue Evans
Holly Ewald
Sarah Falkner
Paul Farinacci
Eva Faye
Jack Featherly
Tony Feher
Jean Feinberg
Robert Feintuch
Joel Feldman
Gabriel Feliciano
Andrew Fenner
Claudia Fernandez
Francisco Fernandez
Cesare Fernicola
Jackie Ferrara
Laura Fields
Elena Figurina
John Filker
Karen Finley
Richard Fiorelli

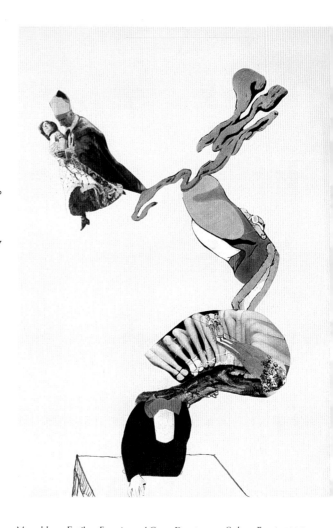

Marcel Jean, Estéban Francès, and Oscar Dominguez, *Cadavre Exquis*, 1935
"In July 1935 I happened to be in Barcelona with Oscar Dominquez and his two friends, the painters Remedios Varo and Estéban Francès....What was there to do for four not very affluent surrealists, after they had explored the Barrio Chino and devoutly visited Guadi's Parc GüellOne main relief against ennui had always been, among surrealists, to draw what we called *"cadavre exquis"*...and in Barcelona we soon resorted to that famous diversion, introducing, however, a different technique: to the surprise of blind collaboration we added the charm of "collage." ...The process was rather exciting and we made *"cadavres"* out of corpses of by-gone publicity until our supply of old magazines was reduced to shreds."
—Marcel Jean, "The Rewards of Leisure," July 5, 1983

The following works will be on view at The Drawing Center, New York and The Corcoran Gallery of Art, Washington, D.C. Artists are listed in sequence from top to bottom. All works are on paper; height precedes width; dimensions are in inches.

Yves Tanguy, Joan Miró, Max Morise, and Man Ray
Nude (Cadavre Exquis), 1926 or 1927
Ink, graphite, and colored crayon, 14 1/4 x 9
The Museum of Modern Art, New York; Purchase

André Breton, Max Morise, Jeannette Tanguy, Pierre Naville, Benjamin Péret, Yves Tanguy, and Jacques Prévert
Figure (Cadavre Exquis), circa 1927
Collage, 11 3/8 x 9
The Museum of Modern Art, New York; Van Gogh Purchase Fund. (page 12)

Salvador Dali, Nusch Eluard, and Paul Eluard
Cadavre Exquis, circa 1930
Colored chalk on black paper, 10 3/4 x 7 5/16
Collection of Robert A. Baird

Tristan Tzara, Valentine Hugo, and André Breton
Cadavre Exquis, circa 1930
Pastel on black paper, 12 1/8 x 9 3/8
Collection of Timothy and Tristan Baum, New York

Lucienne Bloch and Frida Kahlo
Crazy Cat, 1932
Ink on Barbizon-Plaza Hotel stationary, 8 1/2 x 5 1/2
Collection of Lucienne Bloch

André Breton and Valentine Hugo
Cadavre Exquis, 1932
Colored pencil on black paper, 16 x 9 7/8
The Metropolitan Museum of Art, New York;
Gift of James Pilgrim, 1984

André Breton and Valentine Hugo
Cadavre Exquis, 1932
Colored pencil on black paper, 16 x 9 7/8
The Metropolitan Museum of Art, New York;
Gift of James Pilgrim, 1984

Jacques Hérold, Yves Tanguy, and Victor Brauner
Cadavre Exquis, circa 1932
Graphite and collage, 9 7/8 x 7 1/2
Indiana University Art Museum, Bloomington (p. 2)

Frida Kahlo and Lucienne Bloch
(in alternating order)
Exquisite Corpse (Frida Kahlo), circa 1932
Graphite, 8 1/2 x 5 3/8
Private collection
(p. 44)

Frida Kahlo and Lucienne Bloch
Exquisite Corpse (Diego Rivera), circa 1932
Graphite, 8 1/2 x 5 3/8
Private collection
(p. 44)

André Breton, Jacques Hérold, Yves Tanguy, and Victor Brauner
Figure (Cadavre Exquis), 1934
Graphite, 10 1/8 x 6 1/2
The Museum of Modern Art, New York; Kay Sage Tanguy Bequest

Oscar Dominguez, Estéban Francès, Marcel Jean, and Remedios Varo
Untitled (Cadavre Exquis), 1935
Collage, 10 7/8 x 8 1/4
The Museum of Modern Art, New York; F.H. Hirschland Fund

Lino Fiorito
Susan Firestone
R.M. Fischer
Eric Fischl
Ben Fishman
Beverly Fishman
Louise Fishman
Gail Fitzgerald
Daphne Fitzpatrick
Tony Fitzpatrick
David Florimbi
G.E. Foley
John Ford
Guy Forget
Patricia Forrest
Miles Forst
Gudrun Mertes Frady
Stephen Frailey
Edgar Franceschi
Jan Frank
Max Frazee
Helen Frederick
Matt Freedman
Chris Freeman
Christopher French
Nancy Fried
Betsy Friedman
Don Fritz
Carl Fudge
Hiroshi Fujishiro
Yolanda Fundora
Adam Fuss
Joe Fyfe
Charles Gaines
Ellen Gallagher
Paola Gandolfi
Anne Gant
Charles Garabedian
Fernando Garcia Correa
Hernán Garcia Garza
Gary Jo Gardenhire
Andrea Gardner
Peter Garfield
Michelle Gay
Tersea Gejer
Andrew Gellatly
Luke Geller
Danita S. Geltner
Johnathan Genkin
Tom George
Matthys Gerber
Paul Geshlider
Dina Ghen
Steve Gianakos
Mario Giannini
Laurie Giardino
Frank Gillette
Gregory Gillespie
Peter Gilmore
George Gilpin
Max Gimblett
Andrew Ginzel
and Kristen Jones
Lawrence Gipe
David Gissen
Pio Glabis
Judy Glantzman
Andrew Glass
Pam Glick
Mike Glier
Robert Gober
Marc Goethals
Glenn Goldberg
Charles Golden
Deven Golden

Joel Goldstein
Leon Golub
Jeffrey Gompertz
Jose Miguel Gonzales
Casanova
Wayne Gonzales
Felix Gonzalez-Torres
Kathy Goodell
Kirby Gookin
Ron Gorchov
Douglas Gordan
April Gornik
Gotscho
Franco Götte
Marilyn
 Gottlieb-Roberts
Simon Granger
Grace Graupe-Pillard
Gary Graves
Kenn Graziano
Dan Green
Elliott Green
Renée Green
Timothy
 Greenfield-Sanders
Mark Greenwold
Gerry G. Griffin
Bill Griffith
Ray Grist
Rainer Gross
Nancy Grossman
Derrick Guild
Michael Gulas
Robert Gulley
Georgi Gurianov
Marina Gutierrez
Leonie Guyer
Daniel Guzman
Marcia Hafif
Charles Hagen
Joan Hall
Peter Halley
Mary Hambleton
Steven Hammel
Jonathan Hammer
Jane Hammond
John Hansel
Freya Hansell
Chris Hanson
Don Ed Hardy
Rand Hardy
Susan Harlan
Douglas Harling
Karen Harris
Mark Harris
Jan Hashey
Catherine Havemeyer
C. Kenneth Havis
Paula Hayes
Don Hazlitt
David Healy
Hachivi Edgar
 Heap of Birds
Mary Heilmann
Sally Heller
Doug Henders
Dawn Henning
Roni Henning
Alicia Henry
Pieter Hensen
Carol Hepper
Georg Herold
Linda Herritt
Daniel Higgs
Jene Highstein

Estéban Francès, Oscar Dominguez,
and Marcel Jean
Cadavre Exquis, 1935
Collage,
10 1/2 x 6 3/4
Collection of Robert A. Baird

Estéban Francès, Marcel Jean,
and Remedios Varo
Cadavre Exquis, 1935
Graphite, 14 x 11
Collection of Robert A. Baird

Marcel Jean, Oscar Dominguez,
and Estéban Francès,
Cadavre Exquis, 1935
Collage, 8 1/4 x 6 3/16
Collection of Robert A. Baird
(p. 16)

Marcel Jean, Estéban Francès,
and Oscar Dominguez
Cadavre Exquis, 1935
Collage and india ink
10 3/4 x 7 15/16
Collection of Robert A. Baird
(page 74)

Marcel Jean, Estéban Francès,
and Oscar Dominguez
Cadavre Exquis, 1935
Collage, 11 3/8 x 8 3/4
Collection of Robert A. Baird

Remedios Varo, Oscar Dominguez,
and Marcel Jean
Cadavre Exquis, 1935
Collage, 10 1/2 x 6 3/4
Collection of Robert A. Baird

Oscar Dominguez
and Georges Hugnet
Rose Marie (Cadavre Exquis), 1937
Ink on Café de la Post, Paris,
stationery, 10 11/16 x 8 3/16
Collection of Timothy Baum,
New York (page 14)

André Breton, Jacqueline Lamba,
and Yves Tanguy
Cadavre Exquis, 1938
Collage on graph paper, 10 x 6
Collection of Robert A. Baird

André Breton, Jacqueline Lamba,
and Yves Tanguy
Cadavre Exquis, 1938
Collage on graph paper, 10 x 6
Collection of Robert A. Baird

André Breton, Jacqueline Lamba,
and Yves Tanguy
Cadavre Exquis, 1938
Collage on graph paper, 10 x 6
Collection of Robert A. Baird

Jacqueline Lamba, Yves Tanguy,
and André Breton
Cadavre Exquis, 1938
Collage on graph paper,
10 15/16 x 5 1/2
Collection of Timothy Baum,
New York (p. 32)

Joseph Beuys, Eva Beuys, Konrad
Klapheck, and Lilo Klapheck
Die Callas (The Callas), 1961
Graphite, 11 x 8 1/2
Collection of Konrad Klapheck

Lilo Klapheck, Joseph Beuys,
Konrad Klapheck, and Eva Beuys
*Odysseus Circe Betrachtend!
(Ulysses Watching Circe!)*, 1961
Graphite, 11 x 8 1/2
Collection of Konrad Klapheck
(p. 21)

Lilo Klapheck, Gerhard Richter,
Konrad Klapheck, and Ema Richter
*Gerd Richter bei der Einladung
zur echt Schlesichen Küche
(Gerhard Richter Invited to an
Authentic Silesian Meal)*, 1963
Graphite, 11 x 8 1/2
Collection of Konrad Klapheck

Ema Richter, Gerhard Richter,
Lilo Klapheck, and Konrad
Klapheck
Konrad Klapheck, 1963
Graphite, 11 x 8 1/2
Collection of Konrad Klapheck

Ted Joans, Heriberto Cuadrado
Cogollo, Agustín Cárdenas, Jorge
Camacho, Wifredo Lam, Roberto
Matta, and Hervé Télémaque
The Seven Sons of Lautréamont,
1973-80
Ink, 23 1/4 x 7 7/8
Collection of Ted Joans
(p. 22)

CONTEMPORARY WORKS IN THE TRAVELING EXHIBITION

Artists are listed in sequence from top to bottom. The term collage is used to describe paper, printed paper, and newsprint affixed to the paper support. Height precedes width; dimensions are in inches.

Curtis Anderson, Joseph Nechvatal, and Rosemarie Trockel, 1993
Nineteenth-century maps, rubber cement, ink, and heliogravure, with collage, 32 x 17

Ida Applebroog, Celia Alvarez Muñoz, and Matthew Maguire, 1992-93
Watercolor, ink, photocopy, mylar, and charcoal, 18 3/8 x 14

Doug Ashford, Ruth Libermann, and Anita Madeira, 1992-93
Typewritten text and gesso, with collage, 14 3/8 x 10 1/4

Dotty Attie, Mark Tansey, and Steve Mendelson, 1993
Graphite, 22 1/2 x 14 1/4

Julie Ault, Cindy Sherman, and Marc Tauss, 1992
Color photograph and black-and-white photograph, 14 1/4 x 10
(p. 58)

Eric Bainbridge, Fabienne Abrecht, and Drew Beattie and Daniel Davidson, 1992-93
Graphite, masking tape, gesso, ink, fabric dye, charcoal, and lipstick, 22 3/8 x 14 1/4

John Baldessari, Laura Stein, and Cindy Bernard, 1992
Ink, wax, photocopy, graphite, and colored pencil, with rubber stamp, 14 1/4 x 10

Gary Bandy, Arthur Cohen, and Glenn Goldberg, 1992
Acrylic, enamel, watercolor, and graphite, 41 x 26

Bill Barrette, John Wesley, and Rainer Gross, 1992
Photograph, plastic mesh, acrylic, and graphite, with collage, 22 1/4 x 14 3/8
(p. 49)

Jack Barth, Carroll Dunham, and Trevor Winkfield, 1993
Graphite and charcoal, 14 7/8 x 10 3/4
(p. 29)

Georg Baselitz, Brice Marden, and Mary Heilmann, 1993
Graphite and ink, with cutouts, 22 1/2 x 14
(p. 24)

Sergio Bessa, Darren Brown, Vik Muniz, and Kellie O'Bosky, 1993
Ink, photograph, and fabric, with collage; newsprint on verso, 22 1/2 x 14 1/4
(p. 4)

Mark Beyer, Charles Burns, and Peter Saul, 1992
Ink, colored pencil, graphite, photocopy, and mylar, with collage, 14 1/4 x 10
(p. 63)

Max Blagg, Glenn O'Brien, and Keith Sonnier, 1993
Ink, photograph, photocopy, and flocking, 14 3/4 x 10 3/8

Joanne Brockley, Meg Belichick, and Peter Cain, 1992
Photocopy, photo-engravure, ink, and graphite, 14 3/8 x 9 7/8
(page 28)

Peter Burgess, John Boone, and Ken Butler, 1992
Ink, gouache, colored pencil, and photocopy, 14 x 10

William Burroughs, Richard Serra, and Roni Horn, 1992-93
Ink, oil, powdered pigment, and varnish, with collage and rubber stamp, 22 3/8 x 14

Wendy Hirschberg
Ursula Hodel
Jim Hodges
Carter Hodgkin
Cristina Hogan
Sherri Hollaender
Fred Holland
Joel Holub
Jenny Holzer
Eric Holzman
Hori-shin
Horiyoshi III
Roni Horn
Charles Hovland
Nicholas Howey
Kent Howie
Jill Hoy
Arlan Huang
Bettina Hubby
Cannon Hudson
Jon Huffman
Sean Hughes
Richard Hull
David Humphrey
Peter Huttinger
Jon Imber
Jörg Immendorff
Mark Innerst
Shirley Irons
Tomoaki Ishihara
Eliza Jackson
Catherine Jacobers
Henri Jacobs
Mark Jacobson
Yvonne Jacquette
Jack Jaeger
Bruno Jakob
Beth Jansen
Judy Jashinsky
Michael Jenkins
Elisa Jimenez
Luis Jimenez
Suzanne Joelson
Gary Jogardenhire
Erick Johnson
Ray Johnson
Sue Johnson
Kim Jones
Kristin Jones
and Andrew Ginzel
Liz Jordan
Roberto Juarez
Robin Kahn
Sharon Kaitz
Stanley Kaplan
Jane Kaplowitz
Dennis Kardon
Linda Karshan
Deborah Kass
Oleg Katelnikov
Linda Kattuah
Alex Katz
Shelagh Keeley
Andrea Keeton
Darra Keeton
David Kelley
Mike Kelley
Ellsworth Kelly
Karen Kelly
Therese Kenyon
Jon Kessler
Andrei Khlobystin
Julia Kidd
Laura Kikauka
Karen Kilimnik

Beom Kim
Byron Kim
Cheonae Kim
Ashley King
Brent Kington
Ben Kinmont
Michael Kirk
Per Kirkeby
Jean Klebs
Marsha Kleinman
Ed Kloehn
Warren Kloner
Tom Knechtel
Karla Knight
Angela Knightley
Robert Knoke
Tim Knouff
Robert Knoke
Win Knowlton
Jenifer Kobylarz
Katherine Koch
Lisa Jane Kohner
Jeff Koons
Chaine Koppelman
Dorothy Koppelman
Leon Kos
Mark Kostabi
Joseph Kosuth
Oleg Kotelnikov
Pierre Kozakura
Gregor-Torsten Kozik
Joyce Kozloff
David Knudsvig
Stanley Kramer
Sandra Kraskin
Salem Krieger
Philip Krohn
Kathleen Kucka
Nanette Kuehn
Katharine Kuharic
Guillermo Kuitca
Samm Kunce
Carin Kuoni
Gabriel Kuri
Robert Kushner
Carter Kustera
Sowon Kwon
Steven Lack
Justen Ladda
Alix Lambert
Gary Lang
Margaret Lanzetta
Eve Andrée Laramée
Kevin Larmon
Paul Laster
Ian Laughlin
Sharon Lawless
Thomas Lawson
Thi-Linh Le
Ann Ledy
Colin Lee
Soo-Young Lee
Peter Legris
Gary Leib
Barry Leibman
Cary Leibowitz
Patricia Leighton
Annette Lemieux
Willi Lensky
Zoe Leonard
Leone & Macdonald
George Leong
Susan Leopold
Simon Leung
Matrey Levenstein

Richmond Burton, Jan Frank,
and Paul Mogenson, 1992
Ink, acrylic, photocopy,
correction fluid, and watercolor,
22 1/2 x 14 1/4

Mary Carlson, John Lindell,
and Hillary Leone and Jennifer
Macdonald, 1993
Ink, with collage on branded paper,
22 3/8 x 14 3/8

Mary Carlson, Collier Schorr,
and Eve Ashcraft, 1992
Ink, graphite, adhesive tape,
and thread on abraded paper,
with collage, 14 1/4 x 10

Larry Clark, Jeffrey Silverthorne,
and Brian Weil, 1992-93
Black-and-white photographs,
polaroid photographs, and acrylic,
34 x 10 7/8

Chuck Close, Alexis Rockman,
Mark Greenwold, and Dennis
Kardon, 1992
Colored pencil, watercolor, ink,
gouache, and graphite, 30 x 12 1/2
(p. 73)

Robert Colescott, Jane Dickson,
and Robert Yarber, 1992-93
Acrylic and pastel on sandpaper,
26 7/8 x 10 7/8

Chris Costan, Helen Oji, Ford
Crull, and Elisa D'Arrigo, 1992
Photocopy, acrylic, gouache, and
ink, with collage, 22 1/2 x 13 7/8

Cornelia Cottiati, Richard Staub,
and Rick Shaefer, 1993
Photocopy, thread, watercolor,
and graphite, 22 1/2 x 14 3/8

Moyo Coyatzin, Douglas
McClellan, and Marjorie
McClellan, 1992
Charcoal, ink, graphite,
and photocopy, 16 1/4 x 11

John Paul Crangle, Andrew Fenner,
and Lynda Benglis, 1992
Ink and charcoal, 22 1/2 x 14 1/4
(p. 6)

Critical Art Ensemble and
Faith Wilding, 1992
Computer-generated photograph,
photocopy, vellum, ink, and
graphite, with collage,
22 1/2 x 14 1/4

Michael De Jong, Karen Finley,
and Louise Bourgeois, 1992-93
Colored pencil, graphite, water-
color, and ink, 22 1/4 x 14 1/4

Lesley Dill, Sudarshan Shetty, and
unknown Rajasthani artist, 1993
Graphite, ink, and thread, with rub-
ber-stamp and collage, 19 x 2 3/4

Roy Dowell, Tom Knechtel,
Megan Williams, and
Lari Pittman, 1992
Colored pencil, graphite, acrylic,
and spraypaint, with collage,
14 1/4 x 10 1/4
(p. 59)

Jeanne Dunning, Johnny Pixchure,
and Betsy Friedman, 1992-93
Color photograph, acrylic, and ink,
22 1/2 x 14 1/4
(p. 54)

Jack Featherly, Christian
Schumann, and Patrick Thorne,
1993
Acrylic, gouache, ink,
and correction fluid, with collage,
14 3/8 x 10 1/2

Francisco Fernandez, Claudia
Fernandez, Diego Toledo, and
Hector Quinones, 1993
Ink, graphite, acrylic, and water-
color, with collage, 20 x 13 7/8

Cesare Fernicola, Giovanna Dotta,
Agostino Perrini, and Albano
Morandi, 1992
Gesso, colored pencil, ink, and
watercolor, with collage,
22 1/2 x 14 1/4

Eric Fischl, April Gornik,
and Ross Bleckner, 1992
Gouache, watercolor, ink,
and graphite, 14 1/2 x 11 3/8

Lawrence Gipe, Emily Cheng, and David Humphrey, 1992
Watercolor, graphite, and colored pencil, 22 1/2 x 14 1/4
(p. 42)

Leon Golub, Samm Kunce, and Dan Reiser, 1992
Photocopy, ink, color photograph, and gouache, 22 1/2 x 14 1/4

Hachivi Edgar Heap of Birds, Claire Pentecost, and Eve Andreé Larameé, 1992-93
Colored pencil, graphite, and watercolor, with collage, 14 x 10 1/4

Georg Herold, Stephen Prina, and Sowon Kwon, 1992-93
Ink and colored pencil, 14 1/8 x 10

Linda Herritt, Mike Kelley, and Cassandra Lozano, 1992
Novelty plastic eyes, ribbon, Liquid Nails, colored pencil, graphite, watercolor, ink, and metallic ink, 22 1/2 x 14 1/4
(p. 51)

Daniel Higgs, Don Ed Hardy, Eddy Deutsche, and Fred Corbin, 1992
Graphite, ink, and colored pencil, 22 1/2 x 14

Horiyoshi III, Sadatoshi Mikado, and Hori-shin, 1992
Graphite, ink, and colored pencil, 22 1/2 x 14

Jörg Immendorff, David Salle, and Jeff Koons, 1992-93
Graphite, watercolor, and photographs, 22 1/4 x 14 1/4

Bruno Jakob, Harry Philbrick, and Felix Gonzalez-Torres, 1992-93
Water stain, button, thread, acrylic, and color photograph, 22 1/2 x 10

Kim Jones, Leonard Titzer, and Joanne Brockley, 1992
Graphite, ink, acrylic, gesso, gouache, and photocopy, 57 x 20 3/4

Deborah Kass, Patty Cronin, and Roberta Lynn Uhlmann, 1993
Color photocopy, ink, and graphite, 22 1/2 x 14 1/2

David Knudsvig and Nicolas Rule, 1993
Ink and graphite, with cutouts, 20 1/2 x 10 3/8

Ellsworth Kelly and Win Knowlton (in alternating order), 1993
Graphite and charcoal, with collage, 20 3/8 x 10 1/4

David Kelley, John Torreano, and Blake Summers, 1992
Graphite and colored pencil, with erasure, 14 1/4 x 10

Joseph Kosuth, Sarah Charlesworth, and Marc Goethals, 1993
Ink, mylar, color photocopy, and graphite, with collage and embossment, 22 1/2 x 14

Pierre Kozakura, Taro Chiezo, and Hiroshi Fujishiro, 1992
Watercolor, acrylic, and graphite, with collage, 22 3/8 x 14 1/4

Robert Kushner, Kavin Buck, and Deborah Oropallo, 1992
Watercolor, ink, glitter, graphite, oil, and varnish, 22 1/2 x 14 1/8

Justen Ladda, Alex Katz, and Janet Stein, 1992
Acrylic, charcoal, and ink, with collage, 22 1/2 x 14 1/4

Paul Laster, Fabian Marcaccio, and Mary Weatherford, 1992
Ink, correction fluid, and transparent tape, with collage, 14 1/8 x 10

Annette Lemieux, Doug and Mike Starn, and Timothy Greenfield-Sanders, 1992-93
Ink transfer, silverprint on polyester, silicon glue, transparent tape, and silverprint, 14 1/4 x 22 3/8
(p. 68)

Susan Leopold, Alice Aycock, and Kristin Jones and Andrew Ginzel, 1993
Color photocopy, acrylic, gold, ink, and graphite, with collage, 22 1/2 x 14 1/4

Les Levine
Ellen Levy
Trent Leyda
Alexis Leyva Machado
Ruth Libermann
Roy Lichtenstein
Peter Liddell
Siobhan Liddell
Gary Lieb
Rhonda Lieberman
Glenn Ligon
John Lindell
Veronica Lindemann
Lawrence Lipkin
John Lippert
Donald Lipski
Rebecca Littlejohn
Elena Lobatto
Marco Lodoli
Carol Long
Charles Long
Keith Long
Robyn Love
Robin Lowe
Kate Loye
Cassandra Lozano
Bonnie Lucas
Monique Luchetti
Robert Ludwig
Emil Lukas
Eva Lundsager
Markus Lüpertz
Jim Lutes
Chris Macdonald
David Mach
Joshua Mack
Tracy Mackenna
Anita Madeira
Matthew Maguire
Monica Majoli
Pasquale Mallozzi
Patrick Maloney
Vladislav Mamyshev
David Manilow
Story Mann
Vicki Mansoor
Nancy Manter
Francisco Mantevola
Stephanie Mar
Charlie Marburg
Fabian Marcaccio
Carol March
Christian Marclay
Chris Marcoux
Brice Marden
Helen Marden
Fernando Mariscal
Wendy Mark
Jeff Markowsky
China Marks
Melissa Marks
Peter Markus
Megan Marlatt
Nancy Marshall
Robert Marshall
Ruth Marten
Chris Martin
Daniel Martinez
Oleg Maslov
Linda Matalon
Chie Matsui
Bella Matveeva
Claudia Matzko
Tim Maul
Billy Mayer

Dan McArthy
Ruth McBride
Dan McCarthy
Kathleen McCarthy
Marlene McCarty
Douglas McClellan
Marjorie McClellan
Emmett McDermott
Alexandra McGovern
John McLean
Margot McLean
Paul McMahon
Dean McNeil
Winifred McNeill
Elsie Méchant
Andrei Medvedev
Robert Medvedz
Nina Meledandri
Sean Mellyn
Steve Mendelson
Catule Mendes
Xisco Mensua
Earnest Merritt
Katie Merz
Arnold Mesches
Annette Messager
Melissa Meyer
Sadatoshi Mikado
Matt Miller
Melissa Gwyn Miller
Kyrill Miller
Steve Miller
Yong Soon Min
Michael Minelli
Marilyn Minter
Emily Miranda
Caitlin Mitchell-Dayton
Peter Mitchell-Dayton
Chris Mogen
Paul Mogensen
IΔW Pt Mokoh
Regina Möller
Gordon Monahan
Mondo
Jonathan Monk
Gustavo Monroy
Jerry Monteith
John Monti
Gregory Montreuil
Tom Moody
John L. Moore
Tom Moore
Yolanda Mora
Albano Morandi
Gerry Morehead
Robert Morgan
Michael Morgner
Prudence Moriarti
Ron Morosan
Holly Morse
Jill Moser
Kirsten Mosher
Olivier Mosset
Donna Moylan
Cyrilla Mozenter
Xavier Muniain
Vik Muniz
Celia Alvarez Muñoz
Antonio Muntadas
Hajime Muramatsu
Kellie Murphy
Elizabeth Murray
Yves Musard
Peter Nagy
Horiyoshi Nakano

Simon Leung, Harry Philbrick,
and Eliza Jackson, 1992
Acrylic, transparent tape, graphite,
thread, ink, and polyurethane,
with pin-pricks, 22 3/8 x 14 1/4

Les Levine, Judith Weinperson,
and James Siena, 1992
Ink, graphite, and photocopy,
17 x 14

Cassandra Lozano, Roy Lichten-
stein, and Mason Rader, 1992
Ink, colored pencil, metallic ink,
charcoal, and pastel, 22 1/2 x 14

Christian Marclay, Olivier Mosset,
and Alix Lambert, 1993
Acrylic, string, and color photo-
copy, with collage, 22 1/2 x 14 1/4
(p. 55)

Oleg Maslov, Andrei Khlobystin,
and Mikhail Timofeev, 1992
Colored pencil and ink, with
collage and rubberstamp,
22 1/2 x 14 1/4

Marilyn Minter, David Sandlin,
and Sue Williams, 1993
Enamel and graphite, with
silkscreen decals, 22 5/8 x 14 1/4
(p. 71)

Joan Nelson, Robert Gober,
and Sally Webster, 1991
Gouache, graphite, ink, and
rubber chicken legs, 15 x 12 3/4

Helen Oji, Chris Costan,
and Ron Morosan, 1992
Ink, photocopy, and graphite,
with collage, 22 1/2 x 14 1/4

Tony Oursler, James Casebere,
and Charles Golden, 1993
Photograph, planograph print,
graphite, and flocking,
19 1/4 x 10 3/8
(p. 17)

Gary Panter, Steven Evans,
and Michael Jenkins, 1992-93
Ink, graphite, colored pencil,
and masking tape, with collage,
22 3/8 x 14 3/8

Ed Paschke, Mark Innerst,
and Matthew Radford, 1992
Graphite and watercolor,
with collage, 14 1/8 x 10

Ed Paschke, Dan McCarthy,
and Danita Geltner, 1992
Graphite, 22 1/2 x 14 1/4

A.R. Penck, Don Van Vliet,
and Markus Lüpertz, 1993
Graphite and colored pencil,
14 1/8 x 10 1/4

Richard Pettibone, Nancy Becker,
and Nancy Shaver, 1992
Graphite, ink, charcoal, and color
photograph, with rubber-stamp,
14 1/4 x 9 7/8

John Pohl, Georganne Deen,
Don Ed Hardy, and Manuel
Ocampo, 1993
Colored pencil, ink, and gouache,
with collage, 14 1/4 x 10 1/4

Don Powley, Deborah Kass,
and Peter Halley, 1991
Ink and photocopy, with collage,
14 1/2 x 4 1/2

Craig Rapley, Ray Rapp,
and John Toth, 1992
Computer-generated image,
29 x 14 5/8

Brett Reichman, Caitlin
Mitchell-Dayton, and Peter
Mitchell-Dayton, 1993
Gouache, colored pencil, ink, oil,
and graphite, 22 1/2 x 14 1/4
(p. 67)

Josie Robertson, Katharine Kuharic,
and Jean-Philippe Antoine, 1991
Ink, graphite, and tempera,
9 1/8 x 5
(p. 35)

Mario Rossi, Suzanne Treister,
and Peter Liddell, 1992
Ink and enamel, 16 1/2 x 11 3/4

Bradley Rubenstein, Andrea
Champlin, and Daniel Wasserman,
1992
Graphite, oil, and ink, 15 x 11

Jonathan Santlofer, Gary Bachman,
and Per Kirkeby, 1992
Graphite, photocopy, gesso, char-
coal, and oil stick, 22 3/8 x 14 1/4

John Schleslinger, Gordon Brawn,
and Doug Henders, 1993
Photograph, charcoal, varnish,
acrylic, and graphite, 23 3/4 x 9 1/2

Charles Searles, Ray Grist,
and Adger Cowans, 1993
Ink, graphite, and watercolor,
14 1/4 x 10

Carole Seborovski, Andrew Glass,
Beom Kim, and Luca Buvoli, 1992
Graphite, ink, acrylic, Band-Aids,
watercolor, string, brass wire, and
fish line, with collage and cutouts,
25 3/8 x 14 3/8

Eran Shakine, James Elaine,
and Peter Gilmore, 1992-93
Ink transfer, graphite, ink, and pho-
tocopy, with collage, 14 1/4 x 10

Jim Shaw, Simon Leung,
and Fred Holland, 1992-93
Graphite, goldleaf, and thread,
with pin-pricks, 14 1/4 x 9 7/8

Jim Shaw, Sue Williams,
and Nicole Eisenman, 1992
Ink, graphite, and acrylic,
22 3/8 x 14 1/4
(p. 61)

Susan Silas, Claudia Matzko,
and Holly Morse, 1993
Graphite, communion hosts,
and clay, 22 3/8 x 14 1/4

Kiki Smith, Tina Potter, and
Kathleen McCarthy, 1992
Graphite, gold, ink, photographs,
and watercolor, with collage,
36 x 25

Philip Smith, Chris MacDonald,
and James Nares, 1992
Graphite, colored pencil, and ink,
with erasure, 22 1/2 x 14 1/2
(p. 52)

Gary Stephan, Suzanne Joelson,
Emily Cheng, and David
Humphrey, 1993
Graphite, watercolor, and colored
pencil, with collage, 14 7/8 x 10 3/4

Greg Suss, Gary Leib, and Doug
Allen, 1993
Ink and correction fluid,
22 1/2 x 14 1/2

Dorothea Tanning, Ray Smith,
and Francesco Clemente, 1993
Mixed media, 27 x 17
(p. 41)

Robin Tewes, Marlene Dumas,
Richard Artschwager,
and Sean Mellyn, 1992-93
Acrylic, colored pencil, and
graphite, 22 1/4 x 14 1/4

Robin Tewes, Megan Williams,
Gary Panter, and Elliott Green,
1992-93
Acrylic, colored pencil, graphite,
and watercolor, with collage,
14 1/4 x 10 1/4
(p. 62)

Michael A. Tighe, Magdalena
Bergheim, and Markus Döhne, 1992
Silkscreen, acrylic, and varnish,
with collage, 21 3/8 x 14 1/4
(p. 66)

Rosemarie Trockel, Dan Asher,
and Dawn Clements, 1992-93
Photocopy, ink, and gouache,
29 1/2 x 14

Marcia Tucker, Marcel Parrilla,
Ruby McNeil, Joel Wachs,
Dean McNeil, Simon Watson,
Cynthia Plehn, Marsha Kleinman,
Marc Selwyn, and Fran Seegull,
1992
Ink, 8 1/8 x 5 3/4

Alan Turner, Carroll Dunham,
and Laurie Simmons, 1993
Graphite and color photograph,
22 3/8 x 14 1/4

Nicola Tyson, Siobhan Liddell,
and Josephine Pryde, 1992
Gouache and graphite,
with collage, 14 3/8 x 10

Sokhi Wagner, Carter Hodgkin,
Ellen Brooks, and Kunie Sugiura,
1993
Color photocopy, grommets, and
ink, with collage, 25 3/8 x 14 1/4

James Nares
Florence Neal
Joseph Nechvatal
Trevaughn Neeley
George Negroponte
Dona Nelson
Joan Nelson
Rolf G. Nelson
Vernita Nemec
Donald Newman
Laura Newman
Terese Newman
John Martin Newsome
Trish Nickell
Graham Nickson
Heather Nicol
Carsten Nicolai
Olaf Nicolai
Julie Nietsch
Audrey Niffenegger
Gladys Nilsson
Diane Noomin
Nils Norman
Timur Novikov
Thomas Nozkowski
Erik O
Kellie O'Bosky
Glenn O'Brien
Lorraine O'Grady
John Obuck
Manuel Ocampo
John Odom
Kirstene Ogg
Susan Ogu
Helen Oji
Luigi Ontani
Sanda Zan Oo
Dennis Oppenheim
Kristin Oppenheim
Deborah Oropallo
Damián Ortega
Sabina Ott
Thérèse Oulton
Tony Oursler
Vadim Ovchinnikov
Nancy Owens
Richmond H. Page Jr.
Patti Paige
Dena Paige Fischer
Nam June Paik
Irma Palacios
Jaime Palacios
Franc Palaia
Guillermo Paneque
Gary Panter
Catalina Parra
Marcel D. Parrilla
Ed Paschke
John Patterson
Cliffton Peacock
Philip Pearlstein
Marc Peckham
Maurizio Pellegrin
Christian Peltenburg-
Brechneff
A.R. Penck
Mike Penick
Claire Pentecost
Joe Peragine
Cara Perlman
Agostino Perrini
James Perry
Cheryl Peterka
Ed Peters
Gary Petersen
Renee Petropoulos

Richard Pettibone
Jane Pfersdorff
Judy Phaff
Scott Phaffman
Michael Phelan
Harry Philbrick
Richard Phillips
Chris Piazza
Maurizio Pierfranceschi
Stephen Piersanti
Janet Pihlblad
Jody Pinto
Suzan Pitt
Lari Pittman
George Pitts
Johnny Pixchure
Mike Pixley
Cynthia Plehn
Esther Podemski
John Pohl
Randy Polumbo
Rona Pondick
Maggie Poor
Cindy Poorbaugh
William L. Pope
Tina Potter
Anne-Françoise Potterat
Martin Potts
Donald Powley
Paul Pratchenko
Peggy Preheim
Stephen Prina
Rick Prol
Pruitt & Early
Josephine Pryde
Elliott Puckette
Tatiana Pudovochkina-
 Dragomoschenko
Garnett Puett
Rebecca Quayfran
Ellen Quinn
Hector Quiñones
Joan Rabascal
Casey Rachfal
Mason Rader
Matthew Radford
Paul Ramirez-Jonas
Thomas Ranft
Craig Rapley
Ray Rapp
Alan Rath
Nic Ratner
Adam Raymont
Virginia Reath
Catherine Redmond
Shelley Reed
Milo Reice
Elaine Reichek
Brett Reichman
Calvin Reid
Joan Reidy
Lucas Reiner
Dan Reiser
Beth Reisman
Greg Remsen
Jeff Rian
Rene Ricard
Gregory Riches
Walter Riesen
Faith Ringgold
Miguel Angel Rios
Louis Risoli
David Robbins
Jack Robbins
Leslie Roberts

William Wegman, Ansuya Blom,
and Kazumi Tanaka, 1992-93
Ink, carbon, coffee, mold,
and wax, 14 1/4 x 9 7/8

William Wegman, Sarah Seager,
and Thaddeus Strode, 1992-93
Ink, metallic ink, masking tape,
and photocopy, with collage,
22 1/2 x 14 1/4

Lawrence Weiner, Kim Jones,
and Glenn Ligon, 1992
Color photograph and ink,
with collage, 14 1/4 x 10

Millie Wilson, Anne Walsh,
and Jeanne Dunning, 1992
Convex mirror, vinyl type,
hairpiece, fabric, and photocopy,
with collage, 22 1/2 x 14 1/4

Steve Wolfe, Ashley Bickerton,
and Jan Hashey, 1993
Graphite, ink, and watercolor,
22 1/2 x 14 1/4
(p. 46)

Rob Wynne, Mike Bidlo,
Carolee Schneemann,
and Jane Kaplowitz, 1992
Acrylic and photograph,
with collage, 22 3/8 x 14 1/4

Karen Yasinsky, Melissa Marks,
and Laura Watt, 1992
Charcoal, gouache, pastel,
graphite, and acrylic,
with collage,
25 1/2 x 19 3/4

Jim Zivic, Garnett Puett,
and Story Mann, 1991
Graphite and ink on ledger paper,
with collage, 11 3/4 x 9 1/4

Josie Robertson
Joyce Robins
Jeff Robinson
Walter Robinson
Alexis Rockman
Avila Roderigo
Hiram Alfredo
 Rodríguez-Mora
Les Rogers
Lori Rogers
Tim Rollins + K.O.S.
Adam Rolston
Juan Manuel Romero
Kay Rosen
Pat Rosenblad
Barbara Rossi
Mario Rossi
Erika Rothenberg
Salleigh Rothrock
Paul Rotterdam
Stephanie Rowden
Bradley Rubenstein
Nicolas Rule
Christy Rupp
Barbara Rusin
David Russick
Alison Ruttan
Lisa Ruyter
Alison Saar
Betye Saar
Lezley Saar
Manuel Saez-Invierno
Monique Safford
Carol Saft
David Salle
Mark Saltz
Steve Salzman
Charles SanClementi
David Sandlin
Jonathan Santlofer
Christopher Saucedo
Jane Sauer
Peter Saul
Judith Schaechter
William Schefferine
Julia Scher
E. Gray Schiro
Victor A. Schiro
Christina Schlesinger
John Schlesinger
Teresa Schmittroth
Carolee Schneemann
Anne Marie Schneider
Joe Schneider
Mira Schor
Collier Schorr
Patrick Schuchard
Christian Schumann
Barbara Schwartz
Howard Schwartzberg
Carol Schwarzman
Jude Schwendenwien
Jenny Scobel
Vincenzo Scolamiero
Sarah Seager
Charles Searles
Carole Seborovski
Fran Seegull
Josep Segu
Marc Selwyn
Donna Senger
Jinnie Seo
Richard Serra
Rudolph Serra
Teresa Serrano

82

Gilles Shabannes
Art Shade
Rick Shaefer
Phyllis Shafer
Eran Shakine
Nancy Shaver
James Shaw
Judith Shea
Arlene Shechet
Maura Sheehan
Cindy Sherman
Sudarshan Shetty
Christine Shields
Christina Shmigel
Martina Siebert
James Siena
Hollis Sigler
Richard Sigmund
Susan Silas
Amy Sillman
Jeanne Silverthorne
Jeffrey Silverthorne
Regina Silvgra
Gary Simmons
Laurie Simmons
Thomas Simpfendoerfer
Ross Sinclair
Leslie Singer
Sharon Siskin
Elena Sisto
David Slatoff
Hunt Slonem
Wendy Small
Kiki Smith
Michael Smith
Mimi Smith
Philip Smith
Ray Smith
Rick Smith
Seton Smith
Paul Smotrys
Jenny Snider
Ed Sobala
Amy Sokolov
Alan Sonfist
Keith Sonnier
Belinda Sopczak
Irene Sosa
Mario Sotolongo
Buzz Spector
Patricia Spergel
Nancy Spero
art spiegelman
Mary Sprague
Scott A. Stack
Wolfgang Staehle
Andrew Stahl
Doug and Mike Starn
Chrysanne Stathacos
Richard Staub
Walter Steding
Janet Stein
Laura Stein
Susan Stein
Haim Steinbach
Pat Steir
Gary Stephan
May Stevens
Melinda Stickney-Gibson
Jessica Stockholder
Michael Stratton
Beat Streuli
Tom Strider
Thaddeus Strode
Michelle Stuart

Other Texts Cited:

Simone de Beauvoir, *The Second Sex* [1949], H.M. Parshley, trans. (New York: Alfred A. Knopf, 1953), p. 234.

Cadavre exquis, La Révolution surréaliste, 9-10 (October 1, 1927). Cited anonymously throughout the catalogue, translated by Ingrid Schaffner with Mary Ann Caws.

Marcel Jean, "The Rewards of Leisure," quoted in Cynthia Jaffee McCabe, *Artistic Collaborations in the Twentieth Century* (Washington, D.C.: Smithsonian Institution Press, 1984), p. 32.

Armand Lanoux, *Paris in the Twenties,* E.S. Seldon, trans. (New York: Golden Griffen Books, 1960), pp. 38-39.

Man Ray, *Self Portrait* (Boston: Little Brown and Co., 1963), p. 264

Ferdinand de Saussure, *Course in General Linguistics* [1915], Roy Harris, trans. (La Salle, Illinois: Open Court, 1983) p. 154.

Spicy Detective, quoted in S.J. Perelman, "Somewhere a Roscoe...," *The Most of S. J. Perelman* (New York: Simon and Schuster, 1958), p. 15.

.................. *

ISBN 0-942324-06-4
Library of Congress Catalog Number: 93-73978
©1993 The Drawing Center

Photography Credits:

Roland Aellig: p. 19
Michael Cavanagh, p. 2
© Gary Graves: pp. 4, 17, 21, 22, 28, 29, 35, 42, 44, 46, 49, 51, 52, 54, 55, 58, 59, 61, 62, 63, 66, 67, 68, 71, 73
Bill Orcutt: pp. 6, 24, 41
Nathan Rabin: 14, 32

Editor: Jane Philbrick, NY
Design: Bethany Johns Design, NY
Printing: Becotte & Gershwin, Horsham, PA

Kunie Sugiura
Donald Sultan
Blake Summers
Holly Sumner
Greg Suss
Arne Svenson
Natasha Swalow
David Szafranski
Sofiá Táboas
Jorge Tacla
Donna Tadelman
Jude Tallichet
Kazumi Tanaka
Dorothea Tanning
Mark Tansey
Jiang Tao
Glen Tarvis
Lori Taschler
Marc Tauss
Steed Taylor
Andre Tchelistcheff
Rosa Televizor
Gordon T. Terry
Michael Tetherow
Robin Tewes
Ev Thomas
Jim Thomas
Margaret Thomas
Sherry Lee Thomas
Patrick Thorne
Michael A. Tighe
Rirkrit Tiravanja
Mikhail Timofeev
Catherine Tirr
Leonard Titzer
Maggie Tobin
Eric Todley
Sissel Tolaas
Diego Toledo
Fred Tomaselli
Dennis Tompkins
John Torreano
John Toth
Amanda Trager
Cesar Trasobares
Glenn Travis
Suzanne Treister
Rosemàrie Trockel
Constantin Troitsky
Tommy Trosch
Constantine Tsatsanis
Philip Tsiaras
Billie Tsien
Noboru Tsubaki
Roberto Turnbull
Alan Turner
Alessandro Twombly
Nicola Tyson
Kim Uchiyama
Roberta Lynn Uhlmann
Frederico Uribe Botero
Elke Ulmer
Victoria Urman-Kuslik
Gail Vachon
Fahimeh Vahdat
Ivan Valtchev
Anton Van Dalen
Jan van de Pavert
Lily Van Der Stokker
Machteld van Buren
Marieke Van Diemen
Ab van Hanegem
Mark van Proyen
Maurice Van Tellingen
Don Van Vliet